D0583443

# LETTER PERFECT

## THE ART OF MODERNIST TYPOGRAPHY
### 1896–1953

**DAVID RYAN**
Adjunct Curator of Design, The Minneapolis Institute of Arts

THE MINNEAPOLIS INSTITUTE OF ARTS

*Pomegranate*

Published by Pomegranate Communications, Inc.
Box 6099, Rohnert Park, California 94927
800 277 1428; www.pomegranate.com

Pomegranate Europe Ltd.
Fullbridge House, Fullbridge
Maldon, Essex CM9 4LE, England
011 44 1621 851646

© 2001 The Minneapolis Institute of Arts

All rights reserved.

No part of this publication may be reproduced or transmitted in any form or by any means, electronic or mechanical, including photocopying, recording, or by any information storage or retrieval system, without permission in writing from the copyright holders.

**Library of Congress Cataloging-in-Publication Data**

Ryan, David, 1939-
　　Letter perfect : the art of modernist typography 1896–1953 / David Ryan
　　　　p. cm.
　　Accompanies an exhibition of the same title at The Minneapolis Institute of Arts, February 9, 2001 through January 13, 2002.
　　Includes bibliographical references and index.
　　ISBN 0-7649-1615-7
　　1. Graphic design (Typography)—History—20th century—Exhibitions. 2. Type and type-founding—History—20th century—Exhibitions. 3. Posters—20th century—Exhibitions. 4. Modernism (Art)—Exhibitions. 5. Minneapolis Institute of Arts—Exhibitions. I. Minneapolis Institute of Arts. II. Title

　　Z246.R93 2001
　　686.2'2'0904—dc21

　　　　　　　　　　　　　　　　　　　　00-050124

Pomegranate  Catalog No. A598

*Essay/Annotated Labels/Reading List*
David Ryan, Adjunct Curator of Design
The Minneapolis Institute of Arts

*Cover and Book Design*
Graphic Design for Love (+$)

*Letterpress Typography*
Blinc, St. Paul

*Typefaces*
Akzidenz Grotesk, Goshen, Gomorrah

*Photography*
Gary Mortensen, Photographer, The Minneapolis Institute of Arts
Gerry Mathiason, Minneapolis

Printed in Korea

09  08  07  06  05  04  03  02  01    10  9  8  7  6  5  4  3  2  1

# CONTENTS

# LETTER PERFECT
## THE ART OF MODERNIST TYPOGRAPHY 1896–1953

## INTRODUCTION

The essence of art often lies in minute detail. As a basic building material, the printed letter is comprised of assembled shapes and forms. Its smallest element – the contour of a serif, the slope of a curve – can evoke mood and meaning as concisely as the message itself. Today, we're becoming better informed and appreciative of the way words are formally composed in print.

The study of typography and graphic design is immense. It plays a part in so many areas of our cultural and commercial life that it is impossible to summarize every aspect of its history and development in the twentieth century. This survey focuses on one brief moment in the development of modernist typography, from the turn of the century to the outbreak of World War II. As such, it serves as an index to some of the most creative work offered in the history of typographical design.

Shape, outline, color, density, thickness, contour, upper and lower cases are among the elements of typography. The form of one letter, one character, leads to a series of subsequent considerations: proximity, alignment, repetition and contrast; the relationship of one letter to an entire alphabet prompting further decisions about leading, kerning, negative spaces, a consistent character development, and an overall look of continuity in fields of type. Thereafter follow crucial decisions about page format, an overall blanket or zone of type and, certainly not least, legibility. These are the issues of serious discussion among typographers and graphic designers.

While the subject of modernist typography may yet appear rather rarefied, the study of modern typefonts and letterforms has elicited a surprisingly large number of books, articles, and serious discussion within the past decade[1]. Extensive publications have been devoted to the graphic innovations of a single art movement alone, from the anti-art Futurist movement, the antic wordplay of the Dadaists, and the serious, but inventive wayward layout of the Russian Constructivists and Suprematists. Most of their experimental exercises are found in obscure pamphlets and broadsheets handprinted on rather fugitive papers. They are now much in demand by museums and collectors worldwide, an appreciation both deserving and long overdue. The medium of print – or typography – is a principal means of communication while simultaneously conveying the spirit of the times.

In 1987 Norwest Corporation initiated a Modernism collection comprising decorative and applied arts, design and paperworks. Over an eleven-year period a total of 475 works were acquired and made available to the public by means of rotating exhibitions at Norwest Center in downtown Minneapolis. In 1998 the entire collection was generously donated to The Minneapolis Institute of Arts by Norwest Bank Minnesota. Shortly thereafter, a permanent gallery was set aside in the museum explicitly for exhibitions devoted to modernist design. This book is intended as a visual survey of selective works drawn entirely from the

Norwest collection of 140 paperworks, complemented with holdings in the Print and Drawing Collection of the Art Institute. It accompanies an exhibition of the same title at the Art Institute, February 9, 2001 through January 13, 2002. As a survey of modernist typography it is anything but complete. It is intended as a sampler, an introduction to many advances made in typographic design during the sixty-year period, 1896 to 1953, documenting the enormous creative range in typography. This book and the accompanying exhibition are purposely limited to those documents – principally posters – preoccupied with typography. As a hybrid medium, the poster provides a synthesis where painting, drawing, photography and typography come together, influencing each other in the process. Its one-hundred year history coincides with that of modern art itself and it is the dominant art work represented in this survey.

As with most surveys there is no official or agreed beginning. The invention of moveable type was certainly a breakthrough of monumental proportions[2]. Lithography was invented by Aloys Senefelder in 1796, but it was not until the latter part of the nineteenth century that the art of the poster can be said to have begun. The steampress transformed printing from a manual to an industrial process. Thirty copies could be produced in the time it had taken to make one copy by hand. By the mid-nineteenth century, printing presses could produce 25,000 copies per hour. The downside, however, was that every letter had to be encased in metal and set by hand in a case of lines for each page. It was not until 1886 that Ottmar Mergenthaler perfected his Linotype composing machine, a major contribution in the production of printed materials.

Sans serif[3], the first proto-functionalist typeface, contrasted dramatically with the flood of new faces in the picturesque mode. Although associated with the 1920s, sans serif was actually designed in 1816 by English typographer William Caslon and marks the first intrusion of the spirit of modern technology upon typography. It first appeared in a specimen book issued by Caslon that year. The development of a block letter form which adapted well to printing techniques and without embellishment, sans serif was fundamental to the development of modern typography as it moved away from craft technique toward the machine aesthetic. As with William Paxton's revolutionary design for London's Crystal Palace of 1851, sans serif helped created an awareness, if not appreciation, for functional design. Even today, it is used to convey a sense of "modernity." Caslon cut his original sans serif design in a single small size and, not until Vincent Figgins came out with a cruder but much larger version in 1832, did it become popular as a display type. By the 1850s the English printing trade had decided that sans serif was better suited for aggressive advertising than the popular fat faces. A fatal error, however, was mistaking "function" as a criterion for readability. Laboratory reading tests proving the superior legibility of serif type were ignored.

Incorporating examples from several modernist movements (Arts and Crafts, Art Nouveau, Dadaism, De Stijl, Russian Constructivism, and Bauhaus) during this sixty-year period, the survey underscores two fundamental developments in modernist graphic design: first, the steady march toward abstraction in which letter forms begin replacing imagery as the dominant visual element; and secondly, the development and increased use of sans serif typefaces. Both opened the door for an endless vocabulary of fonts and forms. The development was a heady mixture of many influences: creative genius, technological advances, business considerations, readability, and significant breakthroughs made in the major art movements of the period.

Nineteenth-century decorative and ornamented wood and metal letters, flamboyantly designed for ephemeral commercial use, prefigured the progressive ideas of functionality and economy that underlie the modernist ideal, yet they gave rise to the reaction that resulted in change. Victorian type design evolved into proto-modern type, including a range of eclectic typefaces from late nineteenth and early twentieth-century Arts and Crafts, Aesthetic and Art Nouveau movements. The incredible way these typeforms are intertwined with modernist painting, poetry, literature, collage, photo-montage, photography – even architecture – is but one more example of the hybridization of twentieth-century art. Centuries-old disciplines are literally bent out of shape, beyond recognition (as are the letters themselves), resulting in hybrids fascinating for their invention and encouraging further investigation. In examining these works one senses the wonderment and play these pioneers of modern typography must have experienced at the time their work was created. "All doors and windows must be opened wide, so that the musty smell we have had to breathe since childhood can disappear," wrote Bruno Jasienaski in 1921. The quote may be a bit brash, but it certainly hit home.The jarring juxtapositions of type (in painting, sculpture, the graphic arts – in music as well) reflected the tremendous upheavals in politics, society, and world wars. New concepts in art and design in every field were sweeping away exhausted conventions and challenging those attitudes which had little relevance to an increasingly industrialized society.

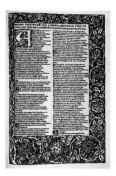

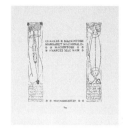

1

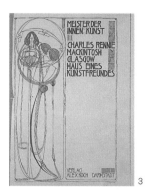

2

3

## ARTS AND CRAFTS
### 1880–1915

By shattering familiar patterns of manufacture, generating new artifacts, and making others obsolete, the industrial revolution forced fundamental reassessments for design. The advent of new inventions and techniques for production raised the question of the appropriate forms for these new objects. A dichotomy developed between a utilitarian approach and one that sought to impose traditional decorative forms on the new artifacts. In fact, one might view the evolution of modern design as the attempt to reconcile the rupture caused by industrialization between function and manufacturing technique on the one hand, and form on the other.

In England, the Arts and Crafts movement had done much to stimulate interest and raise standards in book design, printing, and typography. William Morris founded the Kelmscott Press in 1891 and before his death five years later published fifty-three titles, the last being *The Works of Geoffrey Chaucer,* 1896 (Fig. 1), a model of unified typography and illustration. Morris incorporated poems with wood cuts, integrating words and pictures on a page. Importantly, he and his followers shared a belief in the indivisible unity of the arts. The integration of text and image had long been a fundamental concern, but in this document, it reached a new standard of perfection.

William Morris's Arts and Crafts Movement sought to revive interest in handicrafts and improve the everyday artifacts of the masses. The decline of traditional skills was particularly acute in

book design, provoking a revival of craft-based enterprises in reaction to mass-production. The movement evinced strong social concerns about the alienation of the industrial labor force. Opponents of machine production such as Morris believed that it was directly responsible for a loss of quality and beauty – as well as forcing workers to endure inhumane conditions. But its proposals looked to the past, to the Gothic style as an aesthetic model, and to the abolition of industrialization and a return to craft guilds. Ultimately, its ideals came to be seen as unrealistic since, among other reasons, they tended to result in artifacts only the wealthy could afford.

In contrast, the Glasgow Four (architect Charles Rennie Mackintosh, the Macdonald sisters, and Herbert McNair) developed a graphic style closely related to their architectural details, providing one of the first examples of integrated decorative and graphic arts. It also marked the entry of the architect-designer[4] – as opposed to the illustrator and painter – into the design of posters and graphic design, a phenomenon that would significantly transform the medium and play a crucial role in the development of the art movements to follow. While the two portfolio plates illustrated (Fig. 2, 3) share characteristics typical of Art Nouveau – decorative line, flat patterning, and Symbolist motifs – they also evince a refinement that came to stand for a new beginning separate from those influences growing out of the continent.

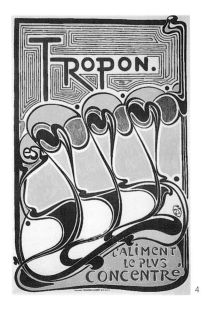

4

5

## ART NOUVEAU
## 1890-1905

The seemingly new forms of Art Nouveau had some ancient precedent in *The Book of Kells* and other illuminated Celtic manuscripts. Caught up in the turn-of-the-century revival of Irish and Scottish culture, designers borrowed from these manuscripts interlaced patterns, ribbon-like lines, coiled spirals, and whiplash curves. Mackintosh especially incorporated Celtic-inspired ribbon patterns into his graphics as noted, but the overriding influence in graphic design springs from the Japanese print. It was a primary source for curvilinear Art Nouveau.

Recognizing the inevitability of industrialization, the Belgian artist Henry van de Velde, one of the creators and the chief theorists of Art Nouveau, turned to the organic forms of nature. Albeit abstracted they had a serpentine quality that ran consistently through his architecture, furnishings, and graphics. His designs for advertising, posters, packaging, and letterheads for the Tropon company constituted the first comprehensive design program for a commercial enterprise. And his famous *Tropon* poster (Fig. 4) illustrates how Art Nouveau as a movement elevated form over content. At the height of the Art Nouveau movement, efforts were made to integrate typeface and letterforms with the sinuous flow of the overall design. French architect-designer Hector Guimard was especially successful in his extensive portfolio, *Le Castel Béranger*, 1900 (Fig. 5), which documents in some sixty-five hand-tinted plates his imposing Parisian building that remains standing today.

Reflecting the period, the Victorian poster was a jumble of historical styles and references – profusion and confusion – its graphic design equally frenetic with illustrations and typography. The Art Nouveau poster, however, became increasingly simplified, often boldly simple. White space (voids) became a positive design element, and designers restricted pattern to specific areas, setting in motion a continual process of refinement. In fact, as with the famous *Tropon* poster, their designs evolved into abstraction. From Japanese prints Art Nouveau designers learned what their Victorian predecessors had not known: how to flatten surfaces and to utilize negative space. Fascinating too are the typefaces that grew out of this period. Eugene Grasset, a Swiss-born French illustrator, designed the first Art Nouveau typeface in 1898. Otto Eckmann, a German artist, followed Grasset's work with graphic experiments for the German Art Nouveau magazines, *Pan* and *Jugend*. As a result of this work, he was commissioned to design a typeface in the Art Nouveau style. Van de Velde also produced an alphabet in which he wove elegant arabesques into script writing. And, shortly thereafter, Peter Behrens, also a German designer, began forging new graphic layout and typefaces which reinforced the rectilinear modes of Art Nouveau. The rapid growth of industrialization and of mass-production had created demands for new kinds of printing, first to efficiently control the processes of production and distribution and later, as production and competition increased, to create and to stimulate demand through advertising.

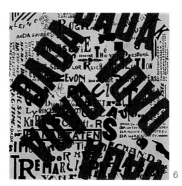

6

## DADAISM
### 1915-1930

During the latter part of the nineteenth century printing fonts grew larger and more exuberant in the pursuit of impact and novelty. Still, overall graphic design remained conservative. It changed only in response to a daring series of avant-garde art movements evolving in Paris at the beginning of the twentieth century, creating a new visual culture which extended beyond the boundaries of fine art. Among the first were the Cubists who pasted newsprint and lettering to their paintings, the advent of collage. Prototypical were the Italian Futurists who sought to expand their activities to all artistic mediums and aspects of daily life. While regrettably not represented in this survey, their work was at the forefront of experimentation. They emphasized assertive communication through both graphic and painted images and word constructions. The leader of the pack, Filippo Marinetti, wrote in his *Manifesto of Futurist Painting* (published in *Le Figaro* in 1909):

> I am against what is known as the harmony of a setting. When necessary we will use three or four columns to a page and twenty different typefaces. We shall present hasty perceptions in italic and express a scream in bold type…a new painterly typographic representation will be born on the page.

The stage was set. Other groups and movements to follow produced polemical manifestos, pamphlets, and magazines which acted both as literary and visual statements of their ideals.

Similarly, one must include Dadaism as a strong and subversive movement. Both groups exulted in disruptive tactics and antic wordplay. The Dadaists, ostensibly against art itself, sought to undermine high art by elevating chance and nonsense as cultural icons. Having literary origins, these two movements focused considerable energy on revolutionizing typography.

Futurism's rejection of tradition and its love of anarchy and chance made it an important influence on Dada. This is evident in the scrambled text in the poster *Kleine Dada Soirée* of 1922 (Fig. 6) by Theo van Doesburg and Kurt Schwitters. Wishing to express chance and the irrational, they produced a characteristically random juxtaposition of disparate images, ideograms, and words, emphasizing the discontinuity of the compositional elements. The Dadaists' appropriation and use of ideograms – the eye or the hand with pointed finger, among others – would reverberate through subsequent graphics, the latter to the point where it became something of a cliché. Both Futurism and Dada embraced photography and film, two essentially new artistic mediums. Early Dada experiments with photomontage were particularly instrumental in extending the interest of the avant-garde to the possibilities of the photograph and its combination with typography and text. Ultimately, however, their experiments were too diverse, crystallizing a sensibility but not a unified style.

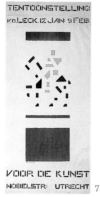

7

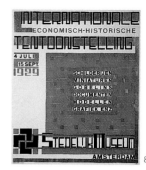

8

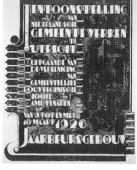

9

10

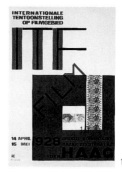

11

## DE STIJL
## 1917–1931

In contrast, other principal art movements following the war—De Stijl, Constructivism, and Bauhaus—concentrated on building a new order, one principally of unification. The Netherlands had maintained a position of neutrality through the Great War and it was here that the modern movement took on a special significance. For a brief period it was a European nerve center where many of the country's artists were actively engaged in all of the art movements mentioned above. Adding to the mix, Frank Lloyd Wright's ideas about functional architecture had been transported to Holland by the Dutch architect Hendrick P. Berlage. The Dutch modern movement was promulgated largely through *De Stijl,* a publication first appearing in 1917. Its title quickly became adopted as the name for the movement to follow.

The Dutch artists of the De Stijl movement sought to unite architecture, painting, design, and typography into an abstract, geometric unity that would harmonize existence. Employing heavy woodblock letters, early Dutch graphics expressed handicrafts and, like the earlier Viennese work, often sacrificed legibility for formal and decorative effect. Their impetus came from the painter Piet Mondrian, who had evolved his own rectilinear, asymmetrical, geometric abstractions from Cubism. Bart van der Leck made an important contribution with his semi-abstract posters (Fig. 7). As with his paintings, they retain a reference to an identifiable object, yet remain highly fragmented. Other artists such as Hendrikus Wijdeveld (Fig. 8) and Antoon Kurvers

(Fig. 9) defined the 1920s graphic look in The Netherlands, which for all its abstraction retained a refined, handcrafted, and occasionally decorative appearance. Piet Zwart (Fig. 10), an architect and furniture designer, became the most inventive exponent of the new Constructivist typography in Holland. Unfortunately, he made very few posters, the best known being *ITF* (Fig. 11) for a 1928 film exhibition. It combines the asymmetrical geometry of De Stijl with a drawing of a filmstrip viewed intently by a set of penetrating eyes. His best work was created for commercial clients, throwaway brochures and magazine advertisements—hence their rarity.

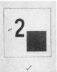
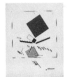
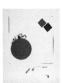

12

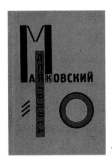
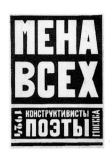

13

14

## RUSSIAN CONSTRUCTIVISM
### 1917–1935

Russian Constructivism emerged at the same time as De Stijl and developed a similar aesthetic, based once again upon the idea of the machine as a primary influence. Unlike the Dutch movement, however, the Russian design events after 1917 had their roots in the political upheaval taking place in that country. Post-revolutionary Russian artists and designers saw their task as one of building or "constructing" new products as well as a new society. Constructivism and Suprematism (initially influenced by Cubism) provided fundamental formal stimuli for architecture, the applied arts, and typography during the 1920s. For the abstract poster, De Stijl and Constructivist designers invented a new graphic vocabulary of column rules, type, and geometric blocks of color and the familiar diagonal axis which created visual tension. The Russian Constructivist El Lissitzky became the greatest single influence on the *new typography.* He produced one of the first completely abstract posters, *Beat the Whites with the Red Wedge,* 1919, followed a year later by his famous children's story, *The Tale of 2 Squares* (Fig. 12). Both works represent early efforts at espousing Communist propaganda by synthesizing Suprematist and Constructivist principles, but the designs thoroughly upstage the message by fragmenting and scattering words. An equally important book was his design for the poet Vladimir Mayakovsky's *For Reading Out Loud,* 1923 (Fig. 13). His work had an immediate influence on Theo van Doesburg, Kurt Schwitters, and, perhaps most important, László Moholy-Nagy. Overall, his graphic designs progressed from pictorial to more purely typographic designs.

Lissitzky's enthusiasm for typography, book and poster design, photography, and film was not an isolated Russian phenomenon. The revolutionary regime's need to arouse, educate, and transform the consciousness of the masses provided a great demand for these mediums. Posters, billboards, and handbills became of primary significance for a vast country with many languages and a high rate of illiteracy. Alexander Rodchenko, who taught at the VKhUTEMAS[5] in Moscow, was central to the development of avant-garde graphics in Russia. Strongly influenced by Kasimir Malevich and Vladimir Tatlin (as were so many other Russian artists), he and twenty-five other Constructivist artists (later called *Productivists*) announced in 1921 they would abandon pure art in favor of the applied arts. While also designing furniture and clothing, Rodchenko made a lasting contribution to advanced typography and photography (Fig. 14).

Inasmuch as Holland had not experienced a social revolution, the ideas advanced in the De Stijl movement remained largely theoretical and rarefied to most of the country. In fact, the artists were greatly dependent upon enlightened patronage for support. Russian designers, however, found a ready outlet for their progressive ideas in a society that demanded immediate change marked by a new visual identity and new products. The Constructivists succeeded in penetrating to the roots of Russian society – the masses – until 1932 when Stalin outlawed abstract art and design.

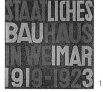

15

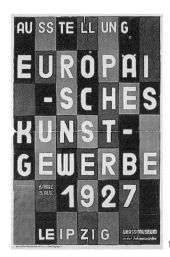

16

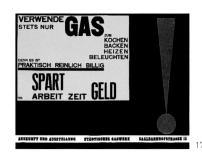

17

## BAUHAUS
## 1919–1933

In 1919, under the direction of Walter Gropius, the two art schools in Weimar, the Grossherzogliche Sächsische Kunstgewerbeschule and the schule für Bildende Kunst, were merged under the new title of Staatliches Bauhaus Weimar.

The innovations made in graphic design at the Bauhaus are among the most radical contributions to twentieth-century design. But the "germination" began earlier. Many of the designers of the Deutsche Werkbund, a highly influential organization founded in 1907 (chief among them, Peter Behrens), sought to raise design standards as well as bring designers and industry together. They stressed new, unified aesthetics which would embrace architecture, the applied arts, and graphics, and reflect modern culture and methods of production. Rapid industrialization had fostered the chaotic growth of the metropolitan city. The reality of the new urban environment was constant transformation and juxtaposition of scale and diverse elements. To the average eye, accustomed to a traditional, harmonious sense of beauty, the new city must have appeared an alienating environment. However, to avant-garde artists and poets it was a realm from which they extracted a new aesthetic, much as artists of the seventeenth century had found an order in the natural landscape, which not so long before had appeared threatening and chaotic.

The Bauhaus played the culminating and perhaps most visible role in the 1920s in the effort to consolidate all the arts of the modern period. Underlying the Bauhaus idea was a cultural and educational agenda that sought to combine the radical, new abstract formal language of the various avant-garde movements with architecture, the applied arts, and industry to make it an integral part of everyday life. Under the school's first director, architect Walter Gropius, the Bauhaus brought together the leading artists and designers of the day. Its unique program carried the Deutsche Werkbund's idea of unifying art and industry a crucial step further – to the radical formal innovations in art as the new source of inspiration.

Bauhaus publications by such leading figures as Herbert Bayer (Fig. 15, 16), Walter Dexel (Fig. 17), and Joost Schmidt are essentially typographical. Asymmetry is used fluently and lettering crosses itself at sharp angles, animating the space and taking on the function previously served by image. Bauhaus typography was not confined to book and poster design. Bayer and Josef Albers created new sans serif typefaces based on geometric shapes. Bayer's *Universal* type and Albers's stencils were developed with display and poster design uppermost in mind. The fonts were developed for international use at a time when Gothic typefaces were still widely used in the German-speaking world. Nevertheless, all Bauhaus publications, as well as most progressive modern printing of the twenties, are in sans serif type.

While it may be argued that sans serif text is less readable, it does convey a clean, no-nonsense, functional appearance. Far more outlandish at the time, the Bauhaus abolished use of capital letters[6] even though the German language requires them not only at the beginning of a sentence but also for every noun. It became a mannerism of the period; in the interest of economy, it was perceived as both more egalitarian and utilitarian. Lastly, the Bauhaus introduced such graphic elements as rules and points in an autonomous way, all intended to enhance communication. Its cerebral, pragmatic approach to advertising, signage,[7] and exhibition design broke new ground, and its legacy remains a vital part of our visual vocabulary today. It was essentially the idea of the machine that inspired the simple, undecorated forms that became the hallmark of progressive thinking in the 1920s and which determined the style that we now associate with the idea of the "machine aesthetic." The Nazi seizure of power put an end to such ideas and experiments. The principal figures of the avant-garde fled primarily to America (Bayer, then Lázló Moholy-Nagy ) and Switzerland (Jan Tschichold), taking with them their experience and their bent for teaching.

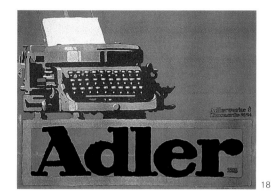

18

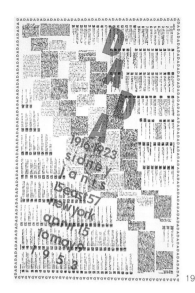

19

## SUMMARY

As an expanding industrial system poured new products onto the market, manufacturers sold them increasingly through newspaper and magazine advertising. Yet posters remained the most dramatic advertising medium, as seen in Lucien Bernhard's earlier poster for Adler typewriters (Fig. 18). Unfettered by the conservatism that afflicted newspapers and magazines, designers had an implied license to experiment. Packaging too was another avenue to be explored. While not represented in this exhibition, many books are devoted to this area of graphic design alone, a kind of folk art in itself. An interesting turnabout, package design was the inspiration for an American art movement of itself, Pop Art, in the sixties.

In 1925 *Gebrauchsgraphik,* a journal of international advertising art, began publication, featuring extensive articles on the new typography and the art of advertising and product photography. Modern graphic design had come of age, and the innovations of the avant-garde were rapidly being appropriated and adapted to commerce. Jan Tschichold, one of the few designers who came to the new typography from a typographical background, was instrumental in this process. In the late twenties he published several books and articles, namely *Die Neue Typographie* in 1928 which became highly influential and sought to analyze and codify the new typography. His importance was not only as a proselytizer for the new typography but as a practitioner who refined it.

The 1920s saw the emergence of modern Swiss graphic design, which has continued as a major source in the field to the present. For most artists, however, photography played a central role, and hence are not included in this survey. Likewise no graphics representing the French-derived Art Deco movement have been included simply because there was a resurgence of interest in incorporating the image in poster designs, a rebirth of pictorial modernism. In most instances typography was subservient to imagery, photography, and decorative elements. The rise of fascism in Europe, among other things, was to cause a significant transfer of artistic talent to America in the 1930s and 1940s. Piet Mondrian and Marcel Duchamp (Fig. 19) were among the many artists fleeing the Nazis who settled in New York.

It is little coincidence that the avant-garde movements represented in this pictorial survey include architect-designers, individuals who tried to expand their newfound visual language among the fine and applied arts, or that their objectives agreed with the aspirations of like-minded reformers in the applied arts[8]. A basic impulse stemming from the discipline of art history united them in an effort to acknowledge the coherence of the various arts—fine and applied—of any given period. It made artists, architects, designers, critics, and theoreticians of the modern era aware of the historical imperative for what was clearly a new epoch.

In the last two decades, poster art has regrettably continued to diminish, first challenged by billboards, then magazine advertising. Today the electronic media has virtually eliminated posters as a viable means of communication and advertising. Occasionally, a museum or corporation will commission paperworks that both surprise and inspire, but the truly creative poster has become increasingly rare. Nevertheless, from the daily flood of printed material there is every evidence that typography in desktop publishing—the printed page in the digital age—is flourishing, actively engaging us ever more in the world of print.

**DAVID RYAN**
Adjunct Curator of Design
The Minneapolis Institute of Arts

## NOTES

1 As indicated in the Suggested Reading List on page 106.

2 Printing with metal type had its origins in the invention of movable type by the fifteenth-century German goldsmith Johannes Gutenberg. Each block has a single letter than can be set, inked, and the relief surface then impressed into paper. The method was an improvement on wood-block printing, not least because one mistake no longer meant the replacement of an entire printing block. Here, a "forme" is made up of the inked type, wedges, and iron frame, or "chase."

3 Taken from the French, "sans" means "without," so sans serif typefaces are without serifs on the ends of the strokes. They are usually monoweight, with little if any visible thick/thin transition in the strokes. The letterforms are the same thickness all the way through. *Helvetica* and *Avant Garde* are two of the better-known sans serif fonts.

4 The foundation for a new twentieth-century approach to the visual arts lies in architecture. Efforts to eliminate a longstanding hierarchy through-out the visual arts was initiated by architect-designers. It is not coinci-dental that so many of them are represented in this survey. The major formgivers of the twentieth century (Frank Lloyd Wright, Charles Rennie Mackintosh, Henry van de Velde, Hector Guimard, Walter Gropius, and El Lissitzky, to name a few) were all architect-designers of the highest rank. As Wright wrote: "We need sciences now where intuition used to guide us." The urge to "construct" that can be seen in the graphic arts of this period stems from rationality, order, clarity, economy, and function, all closely allied to architectural procedure.

5 An acronym for Vysshie gosudarstvennye khudozhestvenno-tekhnicheskie masterskie – Higher State Artistic and Technical Workshops, Moscow.

6 Picking up on one of Lázló Moholy-Nagy's ideas, Herbert Bayer sug-gested abandoning capital letters: "Why two characters, A and a for a single sound a? One character for one sound. Why two alphabets for one word? Why two systems of characters when a single one gives the same result?"

7 Interestingly, one of the most famous logos of the 1920s was the one-word signage, BAUHAUS, running vertically down the facades of the Dessau school building. The sans serif typeface (Universal designed by Herbert Bayer in 1925) was an in-your-face declaration of modernity to the outside world. Whether vertical aligned type should run upward or downward remains an open issue when it comes to architectural signage and book spines. Speaking of logos and signage, one of the world's most successful icons of corporate identity, the Coca-Cola script (*Spencerian*) was designed by the company's bookkeeper, Frank Robin-son. The classic green bottle was not designed by the industrial designer Raymond Loewy as many think. It was given its definitive form as pro-posed by Alexander Samuelson in 1913 (supposedly based on the shape of the cola nut), modified and accepted two years later by a committee at the Root Glass Company of Terre Haute, Indiana, and formally intro-duced in 1915. However, Loewy did design the red metal coke dispenser (a design close to the Evinrude outboard motor housing) seen installed atop American drugstore counters over the years.

8 In yesteryear's phraseology, "Gesamtkunstwerk" (a total or unified work of art), the notion of the complete integration of several art forms such as painting, literature, poetry, music, theater, and opera where none are dominant. It originally grew out of Otto Wagner's concept of music-drama and spread quickly through Secessionist architecture and design. In today's parlance it's called "synergy."

ARTS AND CRAFTS ■ ■

ART NOUVEAU ■ ■ ■ ■ ■

DADAISM ■ ■ ■ ■

DE STIJL ■ ■ ■ ■ ■ ■ ■ ■ ■ ■

RUSSIAN CONSTRUCTIVISM ■ ■ ■ ■ ■ ■ ■ ■ ■ ■ ■ ■ ■ ■

BAUHAUS ■ ■ ■ ■

OTHER DESIGNS ■ ■ ■

**WILLIAM MORRIS** (1834–1896) ENGLISH and
**EDWARD BURNE-JONES** (1833–1898) ENGLISH
*The Works of Geoffrey Chaucer,* 1896.
Kelmscott Press, London, 554 p. with 87 wood-engravings by Edward Burne-Jones.
Borders and initial letters by Burne-Jones and William Morris.
Edition of 438 copies, 13 on vellum and 425 on paper.
Cutter of engravings: W. H. Hooper.
Printer: William Morris at the Kelmscott Press, Hammersmith, London.
Height: 17 x Width: 12 x Depth: 2 5/8 in.
Collection of The Minneapolis Institute of Arts
The Frank P. Leslie Bequest, 67

In the 1880s the reaction against inferior printing and graphic arts began to gather momentum under the influence of William Morris and the Arts and Crafts movement. Having already become involved with the typography of his commercially published books at the Chiswick Press, Morris founded the Kelmscott Press in 1891. A total of fifty-three titles were published before his death in 1896 (the year *The Works of Geoffrey Chaucer* was published). Morris had the foresight to enlist skilled artisans, who provided the technical proficiency, matching them with a well-chosen complement of artistic talent. This book is the ultimate statement of Morris's commitment to reviving print values and celebrating the finest traditions of the graphic arts.

*The Works of Geoffrey Chaucer* contains eighty-seven woodcut illustrations by the Pre-Raphaelite painter Edward Burne-Jones, a close friend of Morris whom he met at Exeter College, Oxford. All of the illustrations are perfectly suited to the text. The book was printed in a folio edition of 556 pages and set in a double-column page of *Chaucer* type (a new, smaller cut of *Troy*) for the text and *Troy* type for the headings. Morris drew the various levels of ornament: numerous initial letters, title-words, and the page and picture borders. Four years in production, this masterwork fulfills Morris's ideal of the book as the perfect embodiment of the mind, soul, and hand of the craftsman at work toward a common goal.

While one might question Morris's contribution to modernist typography, his influence and heritage is evident in twentieth-century layout and graphic design, as can be seen in numerous magazines, books, and publications attentive to minute details and overall quality.

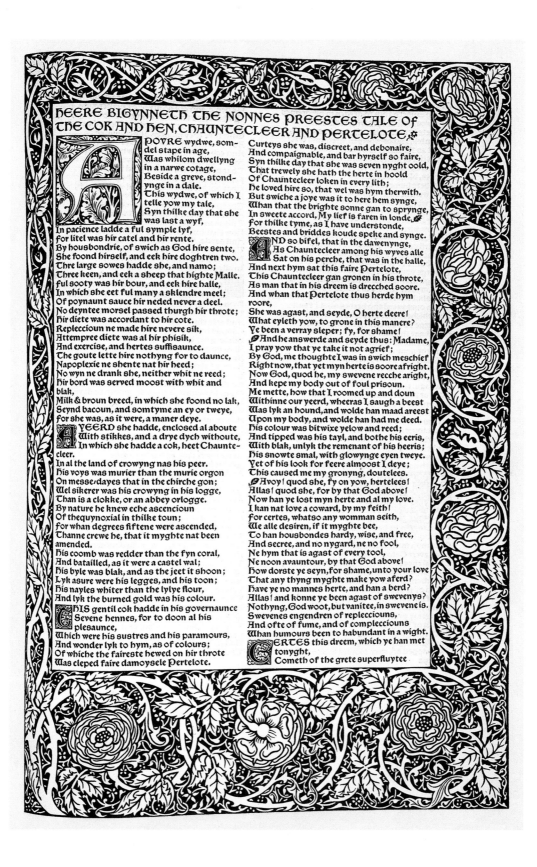

## HEERE BIGYNNETH THE NONNES PREESTES TALE OF THE COK AND HEN, CHAUNTECLEER AND PERTELOTE.

A POVRE wydwe, som-
del stape in age,
Was whilom dwellyng
in a narwe cotage,
Beside a greve, stond-
ynge in a dale.
This wydwe, of which I
telle yow my tale,
Syn thilke day that she
was last a wyf,
In pacience ladde a ful symple lyf,
For litel was hir catel and hir rente.
By housbondrie, of swich as God hire sente,
She foond hirself, and eek hire doghtren two.
Thre large sowes hadde she, and namo,
Three keen, and eek a sheep that highte Malle.
Ful sooty was hir bour, and eek hire halle,
In which she eet ful many a sklendre meel;
Of poynaunt sauce hir neded never a deel.
No deyntee morsel passed thurgh hir throte;
Hir diete was accordant to hir cote.
Repleccioun ne made hire nevere sik,
Attempree diete was al hir phisik,
And exercise, and hertes suffisaunce.
The goute lette hire nothyng for to daunce,
Napoplexie ne shente nat hir heed;
No wyn ne drank she, neither whit ne reed;
Hir bord was served moost with whit and
blak,
Milk & broun breed, in which she foond no lak,
Seynd bacoun, and somtyme an ey or tweye,
For she was, as it were, a maner deye.
A YEERD she hadde, enclosed al aboute
With stikkes, and a drye dych withoute,
In which she hadde a cok, heet Chaunte-
cleer.
In al the land of crowyng nas his peer.
His voys was murier than the murie orgon
On messe-dayes that in the chirche gon;
Wel sikerer was his crowyng in his logge,
Than is a clokke, or an abbey orlogge.
By nature he knew eche ascencioun
Of thequynoxial in thilke toun;
For whan degrees fiftene were ascended,
Thanne crewe he, that it myghte nat been
amended.
His coomb was redder than the fyn coral,
And batailled, as it were a castel wal;
His byle was blak, and as the jeet it shoon;
Lyk asure were his legges, and his toon;
His nayles whiter than the lylye flour,
And lyk the burned gold was his colour.
THIS gentil cok hadde in his governaunce
Sevene hennes, for to doon al his
plesaunce,
Which were his sustres and his paramours,
And wonder lyk to hym, as of colours;
Of whiche the faireste hewed on hir throte
Was cleped faire damoysele Pertelote.

Curteys she was, discreet, and debonaire,
And compaignable, and bar hyrself so faire,
Syn thilke day that she was seven nyght oold,
That trewely she hath the herte in hoold
Of Chauntecleer loken in every lith;
He loved hire so, that wel was hym therwith.
But swiche a joye was it to here hem synge,
Whan that the brighte sonne gan to sprynge,
In sweete accord, My lief is faren in londe,
For thilke tyme, as I have understonde,
Beestes and briddes koude speke and synge.
AND so bifel, that in the dawenynge,
As Chauntecleer among his wyves alle
Sat on his perche, that was in the halle,
And next hym sat this faire Pertelote,
This Chauntecleer gan gronen in his throte,
As man that in his dreem is drecched soore.
And whan that Pertelote thus herde hym
roore,
She was agast, and seyde, O herte deere!
What eyleth yow, to grone in this manere?
Ye been a verray sleper; fy, for shame!
And he answerde and seyde thus: Madame,
I pray yow that ye take it not agrief;
By God, me thoughte I was in swich meschief
Right now, that yet myn herte is soore afright.
Now God, quod he, my swevene recche aright,
And kepe my body out of foul prisoun.
Me mette, how that I roomed up and doun
Withinne our yeerd, wheeras I saugh a beest
Was lyk an hound, and wolde han maad areest
Upon my body, and wolde han had me deed.
His colour was bitwixe yelow and reed;
And tipped was his tayl, and bothe his eeris,
With blak, unlyk the remenant of his heeris;
His snowte smal, with glowynge eyen tweye.
Yet of his look for feere almoost I deye;
This caused me my gronyng, doutelees.
Avoy! quod she, fy on yow, hertelees!
Allas! quod she, for by that God above!
Now han ye lost myn herte and al my love.
I kan nat love a coward, by my feith!
For certes, whatso any womman seith,
We alle desiren, if it myghte bee,
To han housbondes hardy, wise, and free,
And secree, and no nygard, ne no fool,
Ne hym that is agast of every tool,
Ne noon avauntour, by that God above!
How dorste ye seyn, for shame, unto your love
That any thyng myghte make yow aferd?
Have ye no mannes herte, and han a berd?
Allas! and konne ye been agast of swevenys?
Nothyng, God woot, but vanitee, in swevene is.
Swevenes engendren of replecciouns,
And ofte of fume, and of complecciouns
Whan humours been to habundant in a wight.
CERTES this dreem, which ye han met
tonyght,
Cometh of the grete superfluytee

**FRANK LLOYD WRIGHT** (1867–1956) AMERICAN
Page from *The House Beautiful,* 1896–1897.
Text by William Channing Gannet (1840–1923).
Auvergne Press, River Forest, IL.
Published in edition of 90 copies.
Height: 11¾ x Width: 19 in.
Collection of The Minneapolis Institute of Arts
The Modernism Collection. Gift of Norwest Bank Minnesota, 88-43

The Auvergne Press resulted from a partnership of William Herman Winslow (owner of the Winslow Ornamental Iron Works) and Chauncey Lawrence Williams (a Chicago bibliophile). Wright's first architectural commission independent of Louis Sullivan was for Winslow's house (named River Forest); he also designed one for Williams. It was in Winslow's home that Wright and Winslow printed *The House Beautiful.* Being a home operation it is not surprising that Auvergne was one of only two art books produced. It was printed in an edition of only ninety copies.

The decoration that frames each segment of text was intended as a geometric rendering of organic forms. The source of the design was indicated in a booklet, sewn to the front fly-leaf, containing photographic reproductions of grasses and weeds with seed pods; these, said Wright, provided "a decorative pattern to harmonize with the type of the text." The individual pages reveal Wright's development of geometric abstraction using natural motifs. The horizontal row of vertical elements anticipates the arrangement of "window walls" in many of his Prairie School houses. The text consists of a sermon, an appropriate Arts and Crafts treatise on the ideal home, by William C. Gannet, a Unitarian minister.

THERE IS A BIBLE VERSE THAT READS, "A BUILDING OF GOD, A HOUSE NOT MADE WITH HANDS." PAUL MEANT THE SPIRITUAL BODY IN WHICH, HE SAYS, THE SOUL WILL LIVE HEREAFTER. BUT HOW WELL THE WORDS DESCRIBE THE HOME, —A HOME RIGHT HERE ON EARTH!

"EXCEPT THE LORD BUILD THE HOUSE"—

IN A SENSE WORTH NOTING, THE VERY HOUSE ITSELF, THE MERE SHELL OF THE HOME, IS THAT—"A BUILDING OF GOD, NOT MADE WITH HANDS." WATCH TWO BIRDS FORAGING TO BUILD THEIR NEST. THEY PRE-EMPT A CROOK IN A BOUGH OR A HOLE IN THE WALL, SOME TINY NICHE OR OTHER IN THE BIG WORLD, AND, SINGING TO EACH OTHER THAT THIS IS THEIR TREE-BOUGH, THEIR HOLE, THEY BRING A TWIG FROM HERE, A WISP OF HAY FROM THERE, A TUFT OF SOFT MOSS, THE TANGLE OF STRING WHICH THE SCHOOL-BOY DROPPED, THE HAIR THAT THE

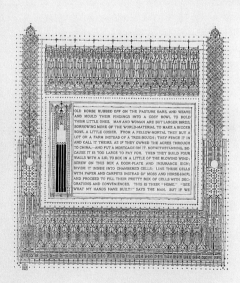

OLD HORSE RUBBED OFF ON THE PASTURE BARS, AND WEAVE AND MOULD THEIR FINDINGS INTO A COSY BOWL TO HOLD THEIR LITTLE ONES. MAN AND WOMAN ARE BUT LARGER BIRDS, BORROWING MORE OF THE WORLD-MATERIAL TO MAKE A BIGGER BOWL A LITTLE COSIER. FROM A FELLOW-MORTAL THEY BUY A LOT OR A FARM INSTEAD OF A TREE-BOUGH; THEY FENCE IT IN AND CALL IT THEIRS, AS IF THEY OWNED THE ACRES THROUGH TO CHINA,—AND PUT A MORTGAGE ON IT. NOTWITHSTANDING, BE-CAUSE IT IS TOO LARGE TO PAY FOR. THEN THEY BUILD FOUR WALLS WITH A LID, TO BOX IN A LITTLE OF THE BLOWING WIND; SCREW ON THIS BOX A DOOR-PLATE AND INSURANCE SIGN; DIVIDE IT INSIDE INTO CHAMBERED CELLS; LINE THESE CELLS WITH PAPER AND CARPETS INSTEAD OF MOSS AND HORSE-HAIR; AND PROCEED TO FILL THEIR PRETTY BOX OF CELLS WITH DEC-ORATIONS AND CONVENIENCES. THIS IS THEIR "HOME." "SEE WHAT MY HANDS HAVE BUILT!" SAYS THE MAN. BUT IF WE

THE HOUSE BEAUTIFUL
CHAPTER ONE
THE BUILDING OF THE HOUSE."

**HECTOR GUIMARD** (1867–1942) FRENCH
*Le Castel Béranger. L'Art dans l'Habitation Moderne,* 1898.
Title page to complete portfolio with 65 plates.
Offset lithography by Librairie Rouam et Cie., Paris, 1898.
Height: 13 1/2 x Width: 17 1/2 in.
Collection of The Minneapolis Institute of Arts
The Modernism Collection. Gift of Norwest Bank Minnesota, 92-30

From the outset, France's premier architect-designer, Hector Guimard, approached his task as an *ensemblier,* drawing together a set of harmonious elements to form a whole. The epitome of this approach is found in his creation of a seven-story apartment block, *Le Castel Béranger* (1894–1897), along Rue de la Fontaine in Paris. After designing the entire building he worked out every detail of its interiors, furnishings, and architectural accessories, all forming an integrated composition. The building remains standing today. Of note are the wrought-iron and copper elements, particularly the grille over the front entrance and the balustrades on the main staircase—asymmetrical compositions of flowing lines which inject a sense of movement into an otherwise static structure. His rigorous attention to detail and his desire to control the appearance of the complete building, both interior and exterior, led him to design such features as floor and wall coverings, lighting fixtures, and a range of fitted and free-standing dark mahogany furniture.

The entire structure and its fittings are documented in a portfolio consisting of sixty-five lithography plates; shown here is the title page. The plates provide architectural and interior details as well as supply the names of the artisans who executed Guimard's designs in ceramic, stained glass, wood, fabric, and wallpaper. The plates along with selected objects from the building were exhibited in the *Exposition Le Castel Béranger,* in which Guimard arranged to promote his newly completed architectural masterpiece. The publicity efforts were quite successful as they led to a commission to design the Métropolitain (Metro) entrance gates, for which he is best known today.

The title page and its typography express Guimard's signature style: free-flowing, organic decoration with an equally sinuous typeface. As with his interiors, it is an inspired blend of rational planning and whimsical effusion. One can well understand why his work was frequently described as *Le Style Guimard* or the *Noodle Style.*

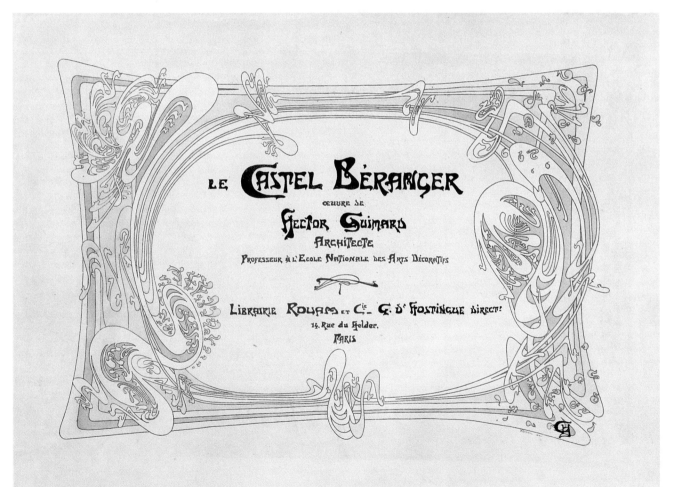

LE CASTEL BÉRANGER

ŒUVRE DE

HECTOR GUIMARD

ARCHITECTE

PROFESSEUR À L'ECOLE NATIONALE DES ARTS DÉCORATIFS

LIBRAIRIE ROUAM ET Cie — G. D' HOSTINGUE DIRECTr

14. Rue du Helder.

PARIS

**HENRY (CLEMENS) VAN DE VELDE** (1863–1957) BELGIAN
*Tropon,* 1898.
Poster / color lithograph.
Full-size version.
Printer: Hollerbaum & Schmidt, Berlin.
Height: 44 3/4 x Width: 30 3/4 in.
Collection of The Minneapolis Institute of Arts
The Modernism Collection. Gift of Norwest Bank Minnesota, 89-84

Writer, theorist, teacher, and practicing architect-designer Henry van de Velde was among the older generation of early modernists who were highly influential in the development of twentieth-century design. One of the few posters designed by van de Velde, this work has become an Art Nouveau icon, one of the most celebrated images of the twentieth century. Many have attributed it to being the first abstract Art Nouveau design. While this is not entirely correct, there is little question that the artist succeeded in completely synthesizing message, typography, and compositional elements.

Initially, the poster appears to be totally abstract, yet its subject and design are cleverly intertwined. Tropon was a Mülheim company specializing in producing foods that included nutrients made from egg whites. Here, van de Velde depicts the egg whites being separated from the yolks. The startling, pioneering use of highly abstracted imagery alluding to a product makes it a conceptual forerunner of the avant-garde posters of the 1920s. With its biomorphic shapes, abstract patterns, and integration of typography into the image, this poster is typical of van de Velde's finest graphic work. During this same period the artist branched out into a wide range of design, including interiors, book designs, metalwork, ceramics, wallpapers, textiles, and — aligning himself to the Dress Reform Movement — women's dresses.

The cardinal objective of Art Nouveau, at least of the kind enunciated by van de Velde in his series of contentious essays, *Les Formules*, was an end to the old bourgeois snobberies which had established a kind of apartheid for crafts and applied arts, closing them off from the "fine" arts. This meant a new elevation of the mass-produced, soiled-by-commerce art of the poster.

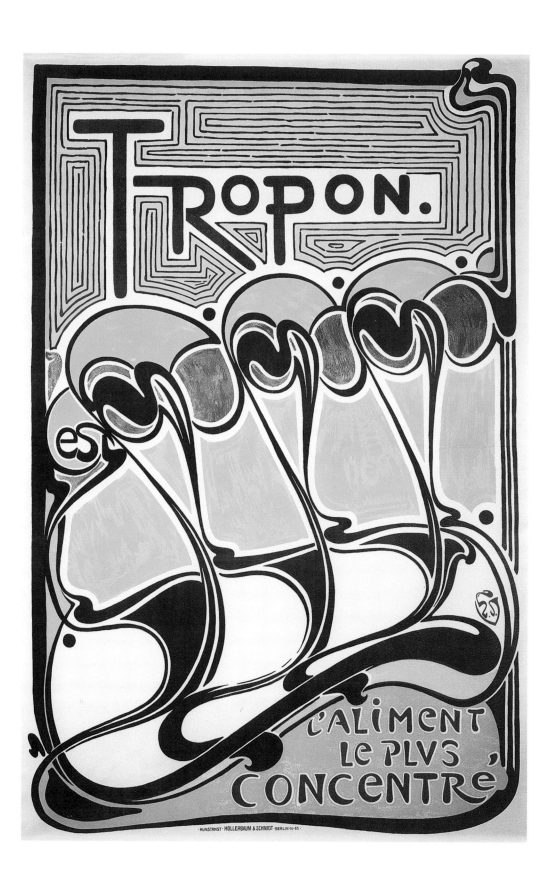

**CHARLES RENNIE MACKINTOSH** (1868–1928) SCOTTISH and
**MARGARET MACDONALD MACKINTOSH** (1865–1933) SCOTTISH
*Ver Sacrum, IV,* (Sacred Spring) *Heft 23,* 1901.
Title page.
Issue devoted to the work of Charles Rennie Mackintosh, Margaret Macdonald Mackintosh, and Frances MacNair. Pp. 395–406. Color plate.
Height: 10 1/8 x Width: 9 1/2 in.
Collection of The Minneapolis Institute of Arts
The Modernism Collection. Gift of Norwest Bank Minnesota, 90-34

*Ver Sacrum* served as the journal for the Vienna Secessionists, documenting their series of exhibitions beginning in 1898. Much of the graphic work reflected the latest tendencies of Jugendstil, the German variation of Art Nouveau. Charles Rennie Mackintosh's renderings are the only works by a contemporary British artist to appear in *Ver Sacrum.* The Vienna visit he and his wife, Margaret, made at that time brought them many new enduring friendships, and it most certainly had a profound effect on subsequent work and direction of the Wiener Werkstätte. In the journal's run from 1898 to 1903, there were a total of twenty-four works illustrated of Mackintosh's work and/or by his immediate circle. It was the Secessionist's eighth exhibition in 1900 that was devoted to European decorative art and which included C. R. Ashbee's Guild of Handicraft, furniture and decorative arts by Mackintosh and his wife, and works by Henry van de Velde.

The title page to *Ver Sacrum IV* is a graphic example of the famed Macintosh collaboration between Margaret and Charles. It is framed on each side by a rectangular box containing a compressed female form—elongated otherworldly pods stretched out with sinuous elasticity. Each dons Margaret's hairstyle of the day, complemented with full-length necklaces. Drawn by her, they are the compelling elements of the page. Her husband's hand-drawn lettering almost goes unnoticed, yet it represents an important intermediate step at the turn of the century: a transition between the flowing calligraphy and script of the past (as captured in Margaret's calligraphic-like figures) and the sans serif typefonts of the future. Typical of many period architect-designers, Mackintosh's letterforms are bounded by upper and lower guidelines. They are slightly compressed, occasionally overlapping in order to accommodate words within the side borders. It is a lettering style familiar to architects throughout the twentieth century, characterized by thin straight lines and in capitals only. Today, such printing skills have become a lost art.

Although Mackintosh never created an alphabet, he designed many variant letters for posters, signs, books, and titles in his drawings. Being hand-drawn, they varied considerably and attempts to standardize them over the years have transformed them into something quite different: exact and repeatable, but mechanized. (The same has been true with the letterforms of Frank Lloyd Wright and other Prairie School architects.) The caption in the bottom of the box frames reads: "Wishing you a good new year from Margaret Macdonald Mackintosh and Charles Rennie Mackintosh."

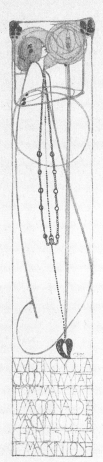

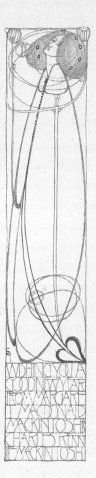

CHARLES R. MACKINTOSH
MARGARET MACDONALD=
☺ ☺ MACKINTOSH ☺ ☺
☺ FRANCES MAC NAIR ☺

☺ ☺ NEUJAHRSKARTEN ☺ ☺

395

**CHARLES RENNIE MACKINTOSH** (1868–1928) SCOTTISH and
**MARGARET MACDONALD MACKINTOSH** (1865–1933) SCOTTISH
*Meister der Innen: Kunst II: Charles Rennie Mackintosh Glasgow Haus Eines Kunstfreundes* (House for an Art Lover), 1901.
Verlag Alex Koch, Darmstadt.
Introduction by Herman Muthesius.
Portfolio of fourteen lithographic polychrome plates with title page.
Title page illustrated.
Height: 20⁷/₈ x Width: 15⁵/₈ in.
Collection of The Minneapolis Institute of Arts
The Modernism Collection. Gift of Norwest Bank Minnesota, 90-27

One of the most influential architect-designers of the modernist movement, Charles Rennie Mackintosh is perhaps best remembered for his design of the Glasgow School of Art (1899–1907). In collaboration with his wife, Margaret, he executed a series of designs in 1901 for an international contest sponsored by the German interior design magazine *Zeitschrift für Innendekoration*. The premise was to design a "House for an Art Lover" (*Haus Eines Kunstfreundes*) for a connoisseur of the arts, complete with interior and exterior plans. The purpose was to elicit "a grand house in a thoroughly modern style."

Mackintosh's initial submission to the contest was disqualified because he had not submitted a complete entry (he failed to submit certain perspective drawings in time). Aside from Mackintosh's entry, the results were disappointing. A first prize was not awarded; Mackay Hugh Baillie Scott was awarded second prize. Mackintosh was subsequently awarded a special purchase prize (600 marks), so the design did receive recognition. Without obligation to a client, it was his one opportunity to express in the most fundamental manner what he felt about art, architecture and design. Almost a century later, the house became a reality. In the fall of 1990 it was erected in Bellahouston Park, Glasgow, and today is open to the public.

The plate illustrated is the portfolio's title page. While the letterforms and box elements on the right are upstaged by the free-flowing, elongated figures on the left (designed by his wife, Margaret), they provide a thoughtful balance. The result is a harmonious blend of the functional and the decorative, as are the interior designs illustrated in the fourteen plates. Moreover, it is the repeated box-like forms—the introduction of geometry—that was to have such an impact on the designs of the Wiener Werkstätte.

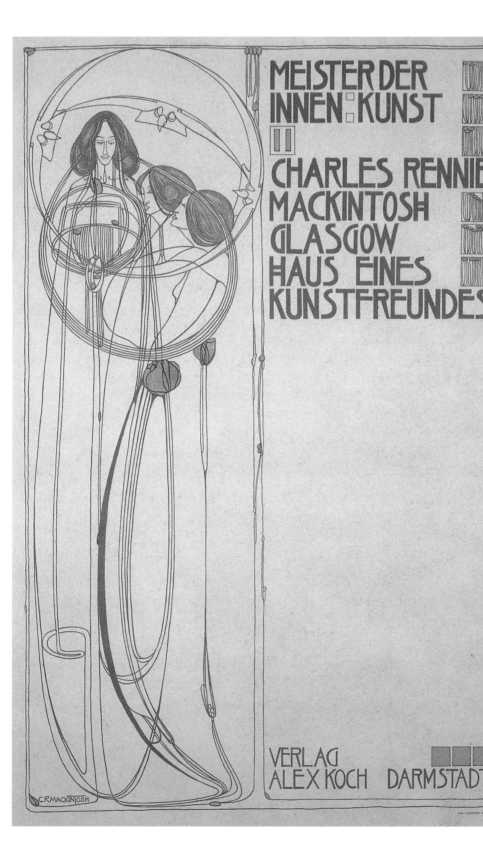

MEISTER DER
INNEN·KUNST

CHARLES RENNIE
MACKINTOSH
GLASGOW
HAUS EINES
KUNSTFREUNDES

VERLAG
ALEX KOCH DARMSTADT

**JOHAN THORN PRIKKER** (1868–1932) DUTCH
*Holländische Kunstausstellung* (Dutch Art Exhibition), 1903.
Poster / color lithograph.
Printer: S. Lankhout & Co., The Hague.
Height: 33⅝ x Width: 47⅛ in.
Collection of The Minneapolis Institute of Arts
The Modernism Collection. Gift of Norwest Bank Minnesota, 89-3

For Johan Thorn Prikker, poster design was not a sideline pursuit. It was an important part of his oeuvre. Dutch by birth, he spent much of his career in Germany. An exhibition poster for the Kaiser Wilhelm Museum in Krefeld, the claw-like motifs and primary colors of this 1903 design convey Prikker's anticipation of the fragmentation and dynamism of German Expression over the languid line of Art Nouveau.

Jugendstil designers rejected traditional methods of typography in favor of unique display typefaces that blended harmoniously with the image. Prikker (one of Holland's significant Art Nouveau proponents) reveals an all-purpose use of a traditional Gothic lettering. (The Germans actually produced the first Art Nouveau typeface, designed by Otto Eckmann for the Klingspor Typefoundary and sold to printers throughout Europe.) The expressive abstract decoration complements the artist's well-known batiked fabrics.

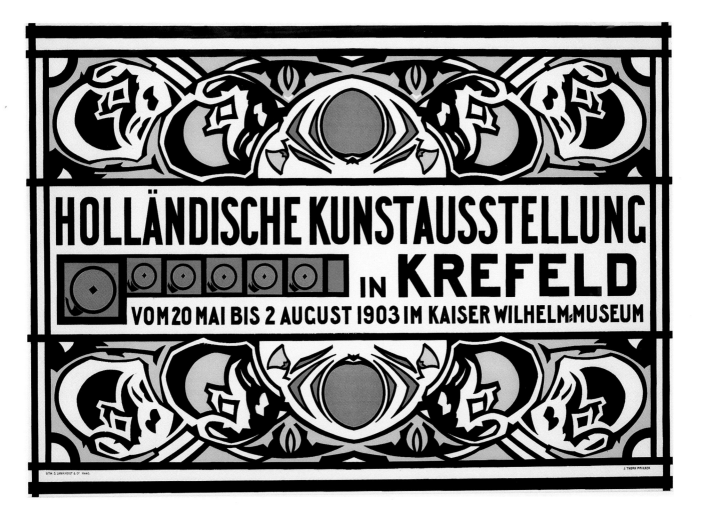

HOLLÄNDISCHE KUNSTAUSSTELLUNG
IN KREFELD
VOM 20 MAI BIS 2 AUGUST 1903 IM KAISER WILHELM.MUSEUM

**ILIAZDE** (Ilia Zdanevitch) (1894–1974) RUSSIAN
*L'eloge de Ilia Zdanevitch,* 1922.
Poster / color lithograph.
Printed for a Dada conference in Paris, May 12, 1922.
Printer: Librairie Universelle, Paris.
Height: 21¹/₂ x Width: 19 in.
Collection of The Minneapolis Institute of Arts
The Modernism Collection. Gift of Norwest Bank Minnesota, 88-112

Ilia Zdanevitch (pen name, Iliazde) was an active member of the Futurist avant-garde group known as *41 degrees* who, collectively, were preoccupied with the phonetic qualities of words. A classic of Dada typography, his most famous poster consists of an apparent blunder, a visual dislocation resembling a broken lithography plate. Quite in keeping with the Dadaist jesture, it is anti-traditional and an in-your-face snub at accepted refinement and taste in printmaking standards and aesthetics.

The text consists of a eulogy by Zdanevitch (nicknamed "The Angel") about himself: "a stupid boor, coward, traitor, idiot, scoundrel and scabrous whore: on his birthday, triumphantly conceived at the University of Degree 41, May 12, 1922." Typically, the poster is a typographical puzzle with varied letters seemingly arranged haphazardly. The text consists of private jokes and allusions comprehensible only to those writers clustered around the group.

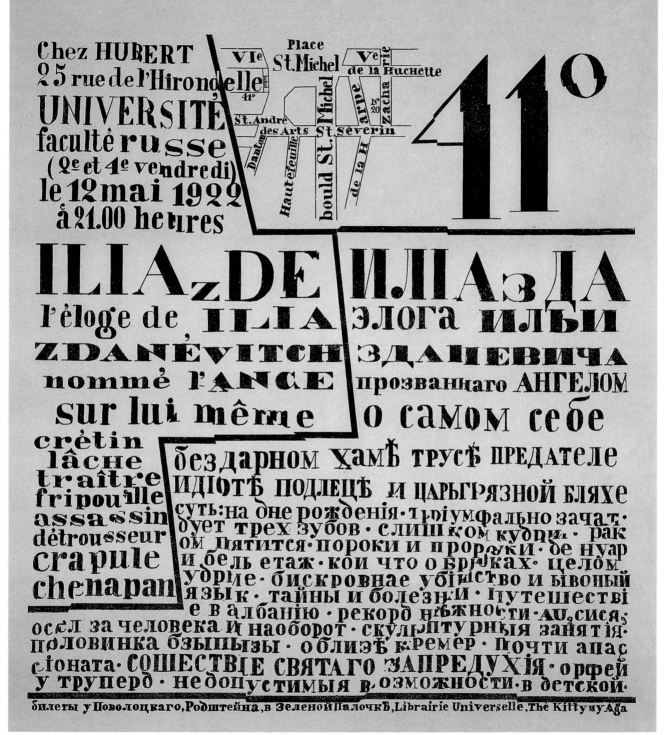

**KURT SCHWITTERS** (1887–1948) GERMAN and
**THEO VAN DOESBURG** (1883–1921) DUTCH
*Kleine Dada Soiree (Small Dada Evening),* 1922.
Poster / color lithograph.
Possibly printed by Theo van Doesburg in The Hague.
Height: 11⁷/₈ x Width: 11³/₄ in.
Collection of The Minneapolis Institute of Arts
The Modernism Collection. Gift of Norwest Bank Minnesota, 89-51

Kurt Schwitters was a leading force behind Dadaism. Using type-fonts alone he created a series of famous collages employing the principles of random choice. In doing so he placed typefonts within a fine art context and opened up the possibility that typography was concerned with far more than function and legibility. In 1919 Schwitters introduced his own form of Dada (called *Merz*) with an exhibition in Berlin's Sturm gallery under the aegis of Paul Klee. After meeting El Lissitzky and Theo van Doesburg at the Hanover Dada congress in 1922, his work became more Constructivist; he was also impressed with and influenced by De Stijl principles after visiting Holland. In 1923, Schwitters began producing his review, MERZ, which appeared intermittently until 1932. It featured contributions from Hans Arp, Piet Mondrian, and El Lissitzky among others, thereby pursuing a direction separate from the international Dada movement.

Printed for a reading by Schwitters for a Dada event in 1922, this important document appears initially to be helter-skelter, a scramble of letters (albeit still highly readable with key words printed prominently) demonstrating the graphic anarchy that typified Dada work. Schwitters and his contemporaries introduced radical new ideas and forms to graphic design—notably, the value of the diagonal as a dynamic device, the effect of layering letters over each other, and the combination of different fonts and hand-lettering to disrupt reading.

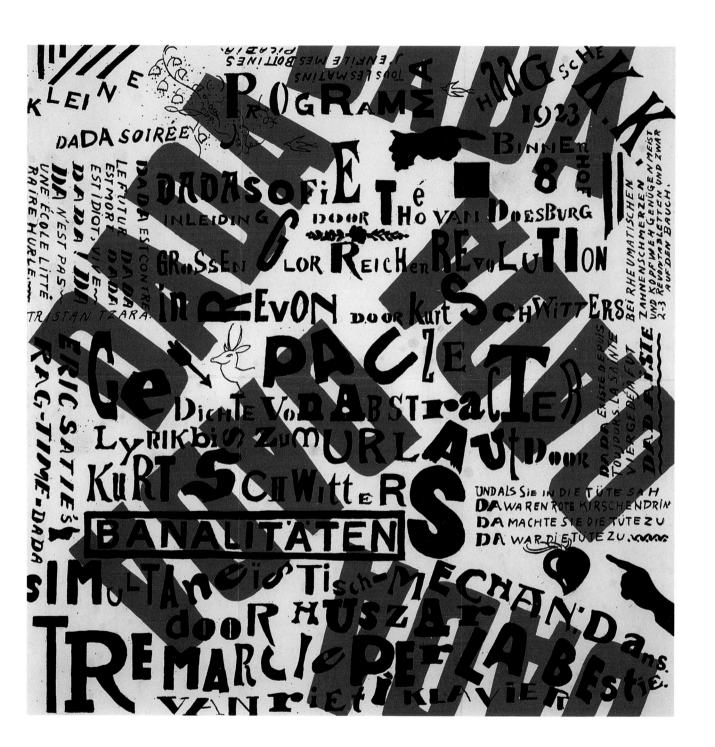

**HENDRIK NICOLAAS (H.N.) WERKMAN** (1882–1945) DUTCH
*The Next Call,* 1925.
Issue #7 of a journal comprised of nine issues.
Printed in black and red with linocuts by W.Alkema & J.v.d. Zee.
Tipped-in reproduction of a van der Zee painting.
Text by Werkman entitled "Face, Profile, Wholesale, Retail."
Height: 10 7/8 x Width: 8 3/8 in. (folded format)
Collection of The Minneapolis Institute of Arts
The Modernism Collection. Gift of Norwest Bank Minnesota, 89-28

Printer, painter, and graphic artist Hendrik Werkman was essentially self-taught. A printer by trade, he experimented with asymmetric composition directly on the bed of his press, using type, rules, and wood furniture fragments. His compositions were of limited edition, produced laboriously by hand with individual variations across the small editions. Werkman's working method was quite unconventional. He reversed the normal process of printing by placing the paper on the bed of an old hand press and then pressing the type and other objects on to it. Each page reveals the effect of the hand behind it, in the precise points of the composition and the depth of the impressions, exploring the detail in the relationship of ink and paper with the wood, metal or other forms used to make the impression. The thickness and irregularity of the inking and occasional smudging were intended as a mockery of professional craft standards. What initially appears to be a casual if not sloppy printing job is well calculated. The relatively casual alignment of his bars and letterforms, irregularly inked (as if they were rubber stamps), purposely invites chance and accident.

In 1923 Werkman initiated a small magazine, *The Next Call,* in which he tried out many of his typographic experiments. The magazine appeared in nine issues between 1923 and 1926; shown here are the cover and an inside page from issue #7. His montage-like method incorporating design elements, the use of found materials, and bold typographic configurations is reminiscent of Dada design practice. Most of his posters were designed for exhibitions of the artists' group *de Ploeg* (The Plough) in Groningen. Werkman was executed by the Nazis for clandestine printing only days before liberation.

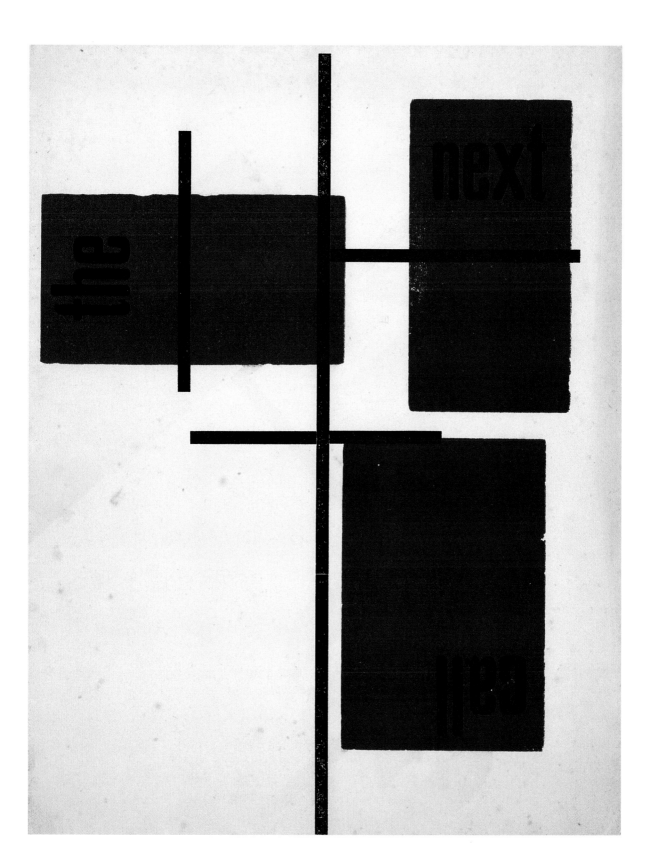

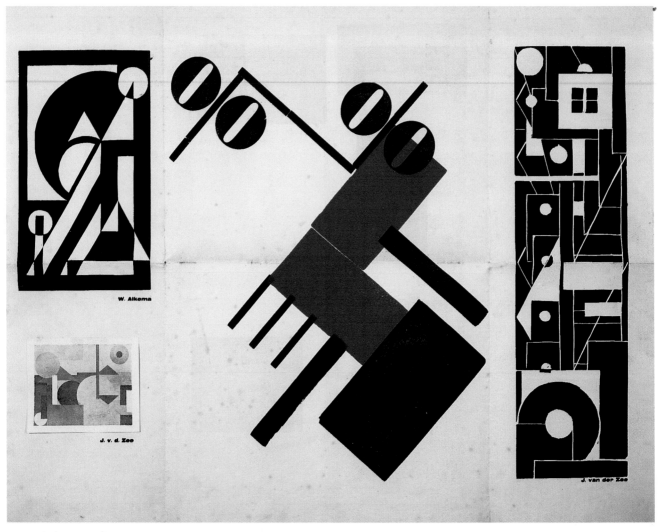

FULL PAGE (UNFOLDED)

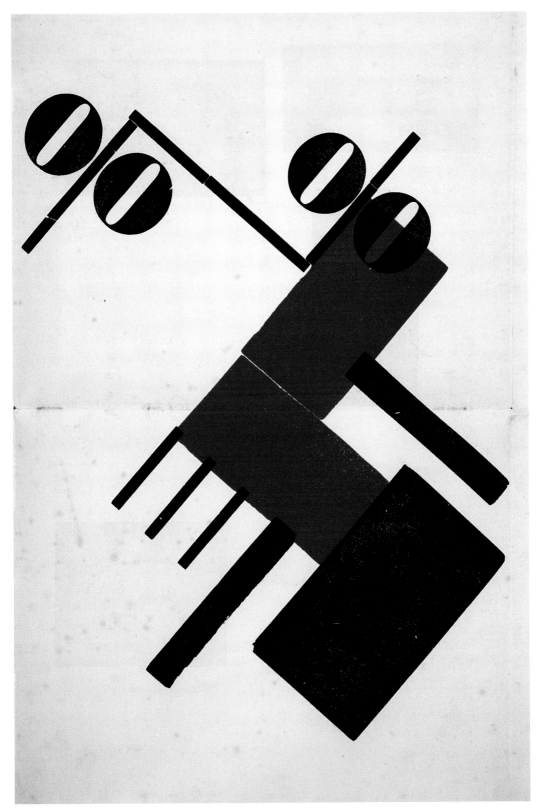

HALF PAGE (DETAIL)

**MARCEL DUCHAMP** (1887–1968) FRENCH
*Duchamp,* 1953.
Poster / lithograph.
Designed by Marcel Duchamp for his one-man exhibition at the Sidney Janis Gallery, New York City, 1953.
Height: 39 x Width: 26 in.
Collection of The Minneapolis Institute of Arts
The Modernism Collection. Gift of Norwest Bank Minnesota, 88-98

Contrasting with the elusive games played in his own Dadaist art, Marcel Duchamp created this striking essay in complex yet rigorously functional typography. With two-color printing on one side of a sheet, Duchamp presented the list of works featured in the exhibition, plus a public announcement clearly readable from afar, serving two purposes in one. The design indicates an astute awareness of combining color and pattern with type. His intelligent handling of the detailed typography ensures that individual parts are readable. From close up, different fonts distinguish the articles from each other, while the alternate strips of light and bold type effectively create white open space as a contrasting shadow around the individual articles being read.

## DADA vs. ART

The attitude of Dada toward art is impregnated with that equivocal spirit of which Dada cultivated the ambiguity more or less wilfully, and if the irrefutable, imperative tone used by Dada to impose its paradox is a proof of its own dynamism, it is this very contradiction that one finds the richness of Dada's own nature.

Dada tried to destroy, so much art, as the idea one had of art, breaking down its rigid borders, lowering its imaginary heights — subjecting them to a dependence on man, to his power — humbling art, significantly making it take its place and subordinating its value to the movement which is also the movement of life.

I comply with your desire, dear Jauss, to write you a few words on the occasion of the opening of the Dada show in your gallery, and like the actor who becomes familiarized with the role of a king, a tyrant, a crowned or a hero, I try to put myself in unison with Dada of 15 years ago. It is not easy for I have changed a great deal and one ready today to believe in angels and what was to our art at that time, seems to me today to be nature. But here is where we take already begins, for nature is Dada.

What you are here is Dada. You also, handsome man, beautiful woman, you are Dada, only you don't know it yourself. Tomorrow Dada will have a different face from today and in that reason will be Dada — Dada is life. Dada is that which changed I would almost say the perpetual change, the eternal return, Heraclites). Dada is life that will transform itself to morrow and behave differently from today. Dada is gas, and anti-Art, laughter, tears, contrast, inconsistency, extremely simple, extremely complicated, practical, edible, luxury or bad, pearly past, square, economic. All these paintings and sculptures, cigars, chairs, windows, tables are Dada. Even sun, Sidney, you are Dada, as are Mary Wigman, Duchamp, Picabia, Man Ray, Ball before the disappearance of Dada actually existed. But "in the significance in Images.

[continued columns of text — largely illegible]

ACKNOWLEDGMENT: The Sidney Janis Gallery wishes to thank Tristan Tzara, Jean Arp, Charles R. Pollock and Jacques Lévesque each for their enlightening footnotes in the catalog.

## FOR THE LOVE OF DADA

This is an article for Dadaism and not against Dadaism. This is an attempt — and not the first one from my side — to take DADA seriously and reject the stupidities that have been said against it.

DADA was one of the great spiritual revolutions of our time. It was a real revolution of the spirit, of the mind and of the soul and it is this revolutionary spirit that has kept it alive and justifies this exhibition.

DADA was no fun and it has been thought of as fun only by the people that think man's fate is directed by comic virtus. DADA's fun — and here I reveal a secret for the thirteen years of the spirit — was a self-ridicule with the purpose of self-realization. The Dadaists were the discoverers of the raw personality, and only the fact that they were a few generations ahead of their time made it impossible for others to understand them.

DADA was a spiritual and psychological revolution whose purpose was to find the NEW MAN. With this purpose I wrote the Fantastic Prayers, Schalaben, the New Man and two dozen DADA manifestos in Zurich and Berlin.

### ZURICH
1  Cabaret Voltaire, 1916. Reprint.
... [numbered catalog entries 1–35]

### HANNOVER
... KURT SCHWITTERS entries

### COLOGNE
... entries

### AMSTERDAM

### OTHER CENTERS

### BERLIN
... HANNAH HÖCH, RAOUL HAUSMANN, JOHANNES BAADER, GEORGE GROSZ entries

### NEW YORK
36  MARCEL DUCHAMP
... entries

### PARIS
... JEAN ARP, MARCEL DUCHAMP, MAN RAY, FRANCIS PICABIA, PAUL ELUARD, TRISTAN TZARA entries

[large overlaid display text:]

# DADA
## 1916–1923
### sidney janis gallery
### 15 east 57
### new york
### april 15
### to may 9
### 1953

TRISTAN TZARA
Paris, January, 1953
Translated by Marcel Duchamp

**BART ANTHONY VAN DER LECK** (1876–1958) DUTCH
*Horseman*, 1919.
Poster / color lithograph on paper with stripped-in typography.
Presumed to be printed by the artist.
Height: 45 5/8 x Width: 22 in.
Collection of The Minneapolis Institute of Arts
The Modernism Collection. Gift of Norwest Bank Minnesota, 88-88

De Stijl's radical minimalism and geometric clarity offered a striking contrast to the complex ornamentation favored by members of the Amsterdam School. Bart van der Leck was influenced by Piet Mondrian, calling his works "Compositions" as Mondrian did. He developed a method of abstraction where he progressively covered over a figure study with white paint until it was reduced to a geometric pattern of rectangular elements, a process he called "decomposing" or "decomposition." In his paintings and graphic work the elements never cross or touch one another, as they did in the work of fellow artists Mondrian and Theo van Doesburg. Characteristically, however, there are no diagonals.

Designed by van der Leck for an exhibition of his work in 1919, this noted poster was adapted from his earlier oil painting of the same design and title. The painting is in the collection of the Rijksmuseum Kröller-Müller. Only four of these posters with the stripped-in typography are known to exist. Van der Leck's letter shapes are not constructed according to a rigid pattern, but distilled from common letter forms and interwoven into a uniform texture. Any resulting loss in legibility is compensated by the charm and childlike manner in which letters and image are drawn—and slowly emerge. For those who may not recognize it, the central image is a knight on horseback. Although other De Stijl members went on to explore completely non-objective painting, van der Leck retained his references to figural composition.

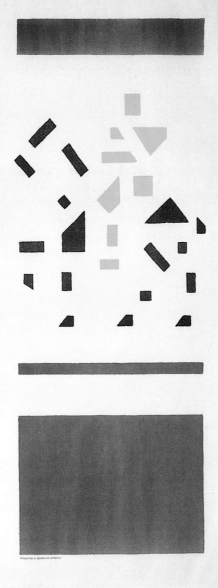

TENTOONSTELLING

v.d. LECK. 12 JAN: 9 FEB:

VOOR DE KUNST

NOBELSTR: UTRECHT

**PAUL SCHUITEMA** (1897–1973) DUTCH
*Advertising leaflet,* c. 1919.
Lithograph.
Height: 11 x Width: 8 3/8 in.
Collection of The Minneapolis Institute of Arts
The Modernism Collection. Gift of Norwest Bank Minnesota, 89-76

While the trade press was still discussing the advantages and disadvantages of photography in advertising, Paul Schuitema was developing an edgy form of layout that introduced many new innovations: the photocollage, photomontage, and cinematic picture narratives with shifting perspectives. From 1926 to 1928 he worked with the Schiedam photographer Jan Kamman, one of the first to explore the full potential of modern photography.

Schuitema worked for the NV Maatschappij Van Berkel Patent in Rotterdam, manufacturers of machine equipment, who gave him a free hand to experiment with new techniques and materials in the designing of their commercial advertising. He designed their trademark and stationery and a wide variety of advertisements, brochures, and catalogues. The aim was to "use the minimum means for maximum effect." Ironically, the speed with which they are perceived is in inverse proportion to the time spent in their elaborate production, particularly the skills required by engravers who made the letterpress blocks.

It is quite likely this work was a preliminary study for more complex designs, variations on themes, one being an advertisement titled, "He Hit the Highest, Berkel's Patent, Rotterdam," produced nine years later. Most of Schuitema's typographic compositions are quite austere, showing a preference for sans serif type and cut-out photographic forms contrasting sharply against red tinted areas. The photomontage became a familiar component of modern graphic design throughout the 1930s.

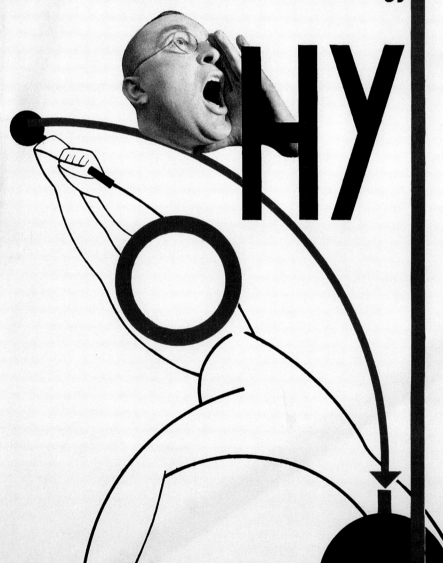

HOOGST

SLOEG HET

HY

RECLAME PAUL SCHUITEMA

**DESIGNER UNKNOWN** DUTCH
*Moderne Kunst,* 1925.
Poster / color lithograph.
Printer: V.D.V.
Height: 19 x Width: 25 in.
Collection of The Minneapolis Institute of Arts
The Modernism Collection. Gift of Norwest Bank, Minnesota, 88-25

The conceptions of De Stijl—horizontal and vertical lines and the use of rectangles, primary colors, and a purified typography arranged in masses—are found in the work of most De Stijl designers. Stripped of all unnecessary decorative elements, or any desire to "beautify," this poster is forthright in its primary function: factual communication.

Although the designer of this poster remains unknown, it serves as a fine example of the principal graphic ingredients identified with the De Stijl movement: a formal, rectilinear composition with the familiar De Stijl letter forms. It was produced for an exhibition of modern art at the Musea der Gem's Grarenhage Aanuinsten Moderne Kunst in 1925.

**PIETER (PIET) ZWART** (1885–1977) DUTCH
*Homage to a Young Girl,* 1925. A typographical experiment.
Edition of 50.
Letterpress.
Signed in pencil lower right: Zwart/1925.
Height: 9¹/₂ x Width: 6⁵/₈ in.
Collection of The Minneapolis Institute of Arts
The Modernism Collection. Gift of Norwest Bank Minnesota, 88-109

Trained as an architect, Piet Zwart described himself as a *typotekt.* He also worked as an interior and furniture designer and as an architectural critic. Throughout a long career which lasted into the 1960s, he designed advertisements and logotypes drawn in geometric lettering for various firms. In 1921 Zwart was first engaged in typographic experiments with which his reputation is now justly linked. A year later he concentrated on mass-produced items, which were exhibited in Paris along with his typography.

The period of the 1920s was particularly, decisive bringing Zwart together with many avant-garde designers and artists who complemented and reinforced his sensibility. During 1922 and 1923 he became friendly with El Lissitzky, most probably meeting him through Kurt Schwitters, then involved with Theo van Doesburg in the early publication of the journal *Merz.* Zwart's free-form inventions, using elements found in the printer's typecase, are derived in some measure from Lissitzky's similar experiments. Zwart became instantly aware of the possibilities of designing directly with typographic material and demonstrated an almost immediate mastery. Over the next ten years, in nearly 300 advertisements, Zwart moved from pure typography to combining photographs and photomontages with type.

In this typographic experiment, he used type, ornaments, and rules in a free, playful composition with words running up, down, across, and diagonally over the page. Devised by the placement of elements from the typecase, this is the only free-form type composition Zwart produced in his career. The composition is based on the four letters of the artist's first name, Z for Zwart, and the date.

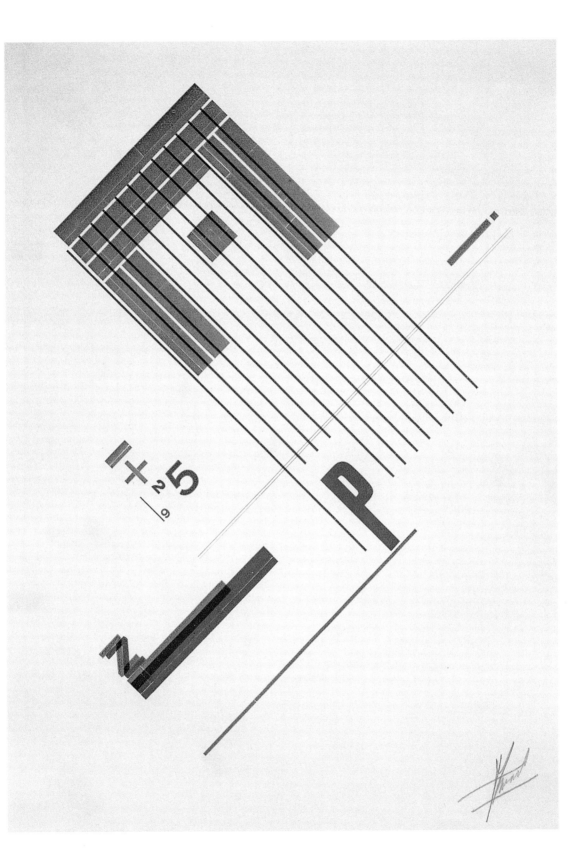

**ANTONIUS (ANTOON) KURVERS** (1889–1940) DUTCH
*Tentoonstelling van Nederlandsche Gemeentewerken* (Exhibition of Dutch Municipal Works in Utrecht), 1926.
Poster / color lithograph on paper.
Printer: Van Leer, Amsterdam.
Height: 38 x Width: 31 in.
Collection of The Minneapolis Institute of Arts
The Modernism Collection. Gift of Norwest Bank, Minnesota, 88-20

Little has surfaced on the work of Antoon Kurvers to date. He was both a lithographer and painter, which is quite evident in this distinctive poster. Active in The Hague until 1908, then in Haarlem until 1918, and subsequently in Amsterdam, he was a contemporary of Theodor Wijdeveld and worked closely with him in designing covers for Wijdeveld's magazine *Wendingen*. As to who was influencing the other is open to debate; it is especially interesting to compare this poster with some of Wijdeveld's pioneering work.

The visual effect of this poster, particularly its painterly quality, provides a rich surface for the distinctive lettering. The contours of the primary form and layering of elements suggest a plaque or movie marquee, and the manner in which the printer's credit line curls around the contour suggests that Kuvers was aware of every minute detail. The subtle block-like pattern of the background and the fuzzy edge printing combine to provide a rich, painterly surface. Limiting the poster to one printing ink is unusual for its time, but the distinctive red coloring (suggestive of bricks or brick facade?) with the natural papertone provide a perfect complement. The poster announces an exhibition of Dutch municipal works in Utrecht.

# TENTOONSTELLING
## VAN
## NEDERLANDSCHE
# GEMEENTEWERKEN
## TE
# UTRECHT

UITGAANDE VAN
DE VEREENIGING
VAN
GEMEENTELIJKE
BOUWTECHNISCHE
HOOFD-
AMBTENAREN

VAN 9 TOT EN MET
18 MAART 1926

# JAARBEURSGEBOUW

ONTWERP EN LITHO ANTK.KURVERS DRUKKERIJ VAN LEER A'DAM

**PIETER (PIET) ZWART** (1885–1977) DUTCH
*ITF* (International Film Exhibition), 1928.
Poster / color lithograph.
Printer: M. V. / J. S. Strang & Company, Drukkerijen, The Hague.
Height: 42 1/4 x Width: 30 5/8 in.
Collection of The Minneapolis Institute of Arts
The Modernism Collection. Gift of Norwest Bank Minnesota, 89-11

In 1926 the Experimental Theater Association, *WijNu,* of The Hague began actively screening avant-garde films in a series of matinees. As a member of the group, Piet Zwart helped organize the 1928 International Film Exhibition to stimulate interest in the new medium. Using the letters ITF as a starting point, Zwart designed a graphic house style for all the exhibition publicity.

In this collage-like composition he has combined a film strip image along with a set of penetrating eyes, a viewer staring intently through the film strip. His use of an arresting (if not unsettling) visual combined with typographic shorthand (particularly the over-sized imprint of ITF) leaves an afterimage, an indelible mark in one's conscious memory. It is a point well taken later by corpora-tions searching for the perfect "unforgettable" logo.

# INTERNATIONALE TENTOONSTELLING OP FILMGEBIED

ITF

14 APRIL
15 MEI
1928

GROOTE KONINKLIJKE
BAZAR ZEESTRAAT 82
DEN HAAG

P. ZWART.

**HENDRIKUS THEODOROUS WIJDEVELD** (1885–1987) DUTCH
*Economische-Historische,* 1929.
Poster / color lithograph.
Exhibition of International Economic History: Pictures, Miniatures, Tapestries, Documents, Models, Graphics; City Museum of Amsterdam.
Dates are listed.
Printer: Druk de Bussy, Amsterdam.
Height: 42 1/4 x Width: 30 5/8 in.
Collection of The Minneapolis Institute of Arts
The Modernism Collection. Gift of Norwest Bank Minnesota, 89-10

By the time of the First World War, artists' statements and writings were being published in exhibition catalogues. Artists were also writing criticism and reviews in magazines such as *De Stijl* and the Amsterdam School magazine, *Wendingen,* founded in 1918. Both consisted of writings by artists and architects rather than by professional critics. The articles—ranging from social housing, the theater, and Hungarian illustration to the work of specific architect-designers such as Frank Lloyd Wright—helped to establish them as "personalities," to cement reputations first in Holland and later in other European countries and the United States.

At the time, Theo Wijdeveld was among the Netherlands' most colorful architects. His earliest work was decorative and similar in style to that of William Morris, generally devoid of a single straight line. It was with the January 1918 issue of his sumptuously produced magazine *Wendingen* that he began creating complex visuals using typographic elements. A total of 116 issues were published, many now famous, all incorporating creative typography and along receiving considerable criticism from traditional typographers.

Wijdeveld generally used simplified forms, yet in a decorative if blocky, architectonic fashion. He was concerned more with form than function. He designed posters, alphabets, and book covers, adapting his typography to a wide range of decorative styles and combining drawn lettering that contrasted with highly constructed typecases. Lettering designed from lines and blocks shortly became his trademark.

# INTERNATIONALE
## ECONOMISCH-HISTORISCHE
# TENTOONSTELLING

4 JULI
15 SEPT.
1929

SCHILDERIJEN
MINIATUREN
GOBELINS
DOCUMENTEN
MODELLEN
GRAFIEK ENZ

Stedelijk Museum

AMSTERDAM

DRUK DE BUSSY, AMSTERDAM                H. TH. W.

**HENDRIKUS THEODORUS WIJDEVELD** (1885–1987) DUTCH
*Architectuur / Frank Lloyd Wright,* 1930.
Poster / color lithograph on paper.
Printer: Joh Enschede en Zonen, Harlem, The Netherlands.
Height: 30 1/2 x Width: 19 3/4 in.
Collection of The Minneapolis Institute of Arts
The Modernism Collection. Gift of Norwest Bank Minnesota, 88-19

This poster was designed by Hendrikus Wijdeveld in consultation with Frank Lloyd Wright for his one-man exhibition that opened in Amsterdam on May 9, 1931. The show documented Wright's architectural works to date and toured both the United States and Europe. The simplified, geometric layout and typography recall the work of the Dutch De Stijl designers as well as the German Bauhaus. Similarly, this design rests solely on typography and geometrical elements, without the aid of imagery. Printing directly from ruled lines is the technique by which Wijdeveld is best known today. He used printers' brass rules to build letters and to construct geometrical ornaments for his pages. In this work large areas of solid color are made out of rules stacked together, the slight space between each rule showing as fine lines of uninked paper. Consequently, the design and the process of reproduction are interdependent.

In 1918, Wijdeveld founded the magazine *Wendingen,* published until 1931. It became the vehicle through which he established his reputation as advocate of the Amsterdam School, an Expressionist movement in architecture that was opposed to the principles of the De Stijl group. Wijdeveld's typeface (oversized, ornamental letters) and decorative borders became known as the *Wendingen Style,* which was influential in Holland for a number of years. His posters illustrate these characteristics as well as his frequent use of rectangular blocks of text that alternate with blank blocks. This poster underscores the influence Wijdeveld had in bringing the work of America's master architect, Frank Lloyd Wright, to the attention of the European public through exposure in *Wendingen.* Due to intense interest in Wright's architecture and interior designs today, this poster is highly coveted by collectors.

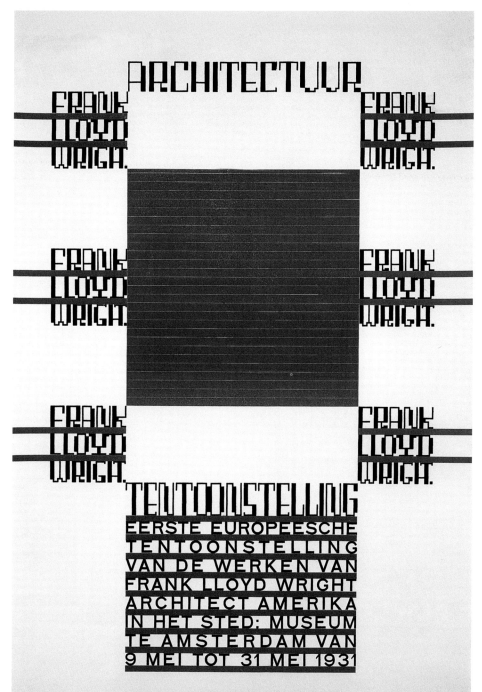

**BART (ANTHONY) VAN DER LECK** (1876–1958) DUTCH
Shopping bag, c. 1935.
Two-color lithograph.
Designed for Metz & Co, Amsterdam and The Hague.
Height: 9¼ x Width: 9 ¼ in.
Collection of The Minneapolis Institute of Arts
The Modernism Collection. Gift of Norwest Bank Minnesota, 88-37

Anyone wanting up-to-the-minute interior decor in the 1930s patronized one of the branches of Metz & Co. for the stark, modern designs of the Thonet brothers or Gerrit Rietveld, glass from Leerdam, and colorful fabrics designed by Sonia Delaunay or produced by the fabric manufacturer Weverij De Ploeg. Since 1900, Metz & Co. had been under the far-sighted management of J. de Leeuw, who imported the internationally renown Liberty fabrics from London. In the 1920s he introduced stylish, deluxe furniture from Paris and Vienna while gradually taking on more Dutch industrial artists.

De Leeuw's introduction to Rietveld and the painter Bart van der Leck around 1930 brought renewed vigor to the store. Van der Leck designed the firm's logo as well as an assortment of bags and boxes in his inimitable style of fragmented letterforms with primary colors, all properly reflecting Metz & Co.'s combination of exclusivity and the avant-garde. The bag's restraint and air of sophisticated modernity is no less contemporary today.

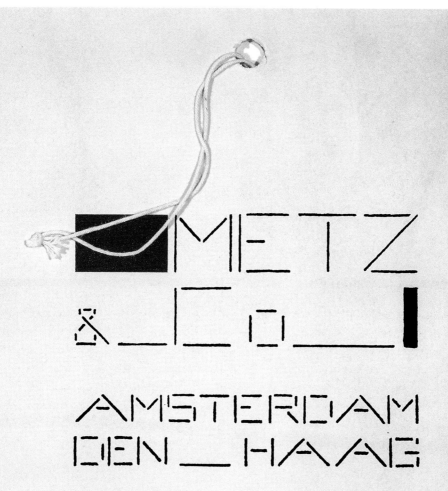

**BART (ANTHONY) VAN DER LECK** (1876–1958) DUTCH
*Het Vlas* (The Flax), 1941.
Author: Hans Christian Andersen.
Designed and illustrated in color with a decorated wrapper by van der Leck.
Bookplate on title page.
Number 161 of 500 copies.
Amsterdam: N.V. de Spieghel. Printer: De Usel, Deventer.
Height: 9 3/4 x Width: 7 in.
Collection of The Minneapolis Institute of Arts
The Modernism Collection. Gift of Norwest Bank, Minnesota, 88-111

The only fully illustrated book of the De Stijl movement, *Het Vlas* was designed by Bart van der Leck in 1941. Illustrated with small drawings and geometric designs in primary colors, it represents one of the most sophisticated children's books of the modern era. Van der Leck's rendering of Hans Christian Andersen's fairy tale reflects his lifelong preoccupation with the tenets of De Stijl and the strictures of Piet Mondrian. His letterforms are not constructed on a rigid grid but condensed from accepted forms and then reassembled into an even weave. What was lost in readability was compensated for by inviting, childlike drawn letters. The fragmented letters and images created with their broken contours are played off against rules, squares, and rectangles that together provide an overall abstract composition.

Van der Leck remained true to his mathematical approach to images, designing or systematically "constructing" each book page as if it were a building, adding accents of primary colors. For most of his career, graphic work was a marginal activity. Aside from painting, his interest lay chiefly in architecture, stained-glass windows, and industrial design. From 1928 onwards he received a series of commissions for the Amsterdam firm, Metz & Co., designing carpets and advising on color schemes.

# HET VLAS.

HET VLAS STOND IN BLOEI. DAT HEEFT ZULKE PRACHTIGE BLAUWE BLOEMEN, ZOO ZACHT ALS DE VLEUGELS VAN EEN MOT EN NOG VEEL FIJNER.

DE ZON SCHEEN OP HET VLAS EN DE REGENWOLKEN SPOELDEN HET AF, EN DAT WAS NIET ZOO GOED VOOR HEM, ALS HET VOOR KLEINE KINDERS IS OM GEWASSCHEN TE WORDEN EN DAN EEN KUS VAN MOEDER TE KRIJGEN; ZE WORDEN DAAR TOCH VEEL MOOIER VAN.

EN DAT WERD HET VLAS OOK.

„DE MENSCHEN ZEGGEN DAT IK ER ZOO BIZONDER GOED BIJ STA",

ZEI HET VLAS, „EN DAT IK ZOO MOOI LANG WORD, ER ZAL EEN PRACHTIG STUK LINNEN VAN MIJ KOMEN! NEEN MAAR, WAT BEN IK GELUKKIG! IK BEN VAST DE ALLERGELUKKIGSTE VAN ALLE- MAAL! IK HEB HET ZOO GOED, EN IK WORD WAT!

„HOE DIE ZONNESCHIJN OPMONTERT EN HOE DIE REGEN SMAAKT EN VERFRISCHT! IK BEN ONVERGELIJKELIJK GELUKKIG, IK BEN DE ALLERGELUKKIGSTE!"

„JA, JA, JA!" ZEIDEN DE HEININGPA- LEN, JIJ KENT DE WERELD NIET, MAAR DAT DOEN WIJ, ER ZIJN KNOESTEN IN ONS!" EN TOEN

**WILLEM JACOB HENRI BEREND SANDBERG** (1897–1984) DUTCH
*De Stijl 1917–31,* 1950.
Poster / color lithograph.
Height: 19 1/2 x Width: 27 1/2 in.
Collection of The Minneapolis Institute of Arts
The Modernism Collection. Gift of Norwest Bank Minnesota, 89-52

Inspired by the work of Piet Zwart and Hendrik Werkman, Willem Sandberg was a practitioner of *Die Neue Typographie.* He was appointed curator of modern art at the Stedelijk Museum, Amsterdam (1937–1941), and subsequently director (1945–1962). There he personally designed over 300 catalogues and numerous posters, including this work.

With his inspirational personality and his exceptional position as museum director and designer, Sandberg contributed greatly to Dutch graphic design after the war. He regarded "his" Stedelijk Museum as a means of breaking through the Netherlands' cultural isolation and raising the issue of the social role of the arts. He introduced the public to art events abroad and to radical developments in the recent art of their own country. This agenda carried the Museum to the center of the international art world.

This poster was designed for a De Stijl exhibition at the Stedelijk Museum in 1950. Typical of Sandberg's work, it is characterized by asymmetrical layouts and contrasts of color, texture, and typographic scale. He preferred coarse, open-grained paper, large woodblock type, and roughly torn letter forms, the latter often juxtaposed with crisp uniform type.

schilderskunst
architectuur
meubelen

# DE STIJL
## 1917-31

stedelijk museum a'dam

tot 1 october

**NATALIYA GONCHAROVA** (1881–1962) RUSSIAN
*Gorod / Stikhi* (The City: Verses), 1920.
55p. Lithographs, woodcuts and printed text.
Poems by Alexander Nikolaevich Rubakin.
Printed on Vergé d'Arches paper with printed paper covers, Paris.
Height: 7 1/8 x Width: 4 5/8 in.
Collection of The Minneapolis Institute of Arts
Gift of Bruce B. Dayton, B.89.2

As expressed so well by Paul Schuitema (p. 042), Nataliya Goncharova employs "minimum means for maximum effect" in her typographical design appearing on the cover of this small book of verses. Direct and dramatic, Goncharova's combination of what appears to be an upside-down "L," the direction of the two "o's," the accents and the angular feet on the capital "A," along with intriguing footnote numerals convey immediacy, allure, and mystery all in one. Moreover, the upper heading appears to be a modernist hieroglyphic. The cover design is among the most inventive and striking typographical compositions in the entire collection.

Numerous drawings by Goncharova complement the text providing insights into the scope of her work up to 1920, ranging from Neo-Primitivism to Futurism to theatrical lyricism. In particular, the Futurist drawings are convincing and powerful; in them she exploits the contrast of dark and light for expressive, dramatic effects. The hand-printed text reveals a delicate, rhythmic stroke which is enlivened by the marginalia and full-page illustrations. Together, the lyrical poems and graphics convey the impression of a city on the move yet encompassing the human qualities of urban life.

ПАРИЖЪ
1920

**EL LISSITZKY** (Lazar Markovich Lissitzky) (1890–1941) RUSSIAN
*Pro Dva Kvadrata* (The Suprematist Tale Of Two Squares), 1922.
Pamphlet with lithographs printed in black and red.
16p., unnumbered with 9 illustrations.
Printed paper covers.
Berlin, 1922.
Edition included 50 numbered and autographed copies.
Printer: E. Haberland, Leipzig. Verlag Skythen.
Height: 8 3/4 x Width: 10 15/16 in.
Collection of Minneapolis Institute of Arts
The Ethel Morrison Van Derlip Fund, B.89.3

Conceived in Vitebsk in 1920 and published two years later in Berlin, this story is dedicated "to all, all children" and — in a clever graphic presentation — represents the imposition of order and clarity (here represented as the red square) on chaos (the black square). Recognizing that children can handle abstraction while "conditioned adults must be content with passive enjoyment," El Lissitzky relates a story using elemental Suprematist compositions (a red square, symbol of life and the new revolutionary order with its limitless possibilities), operating against a black square (signifying the old order, chaos, egotism and death). It is a story in which social forces clash, the reference to the Russian Revolution and the triumph of Bolshevism being quite clear.

In his essay *Typographical Facts,* Lissitzky explains: "In this tale of two squares I have set out to formulate an elementary idea, using elementary means, so that children may find it a stimulus to active play and grown-ups enjoy it as something to look at. The action unrolls like a film. The words move within the fields of force of the figures as they act: these are squares. Universal and specifically plastic forms are bodied forth typographically." The dynamic arrangement of the forms (including text) relates to Lissitzky's experiments with the *Proun* series (ninety-eight works of various media self-described as "waystations between painting and architecture"), in which geometric forms interact in space.

Created at the Vitebsk Art School and printed in Berlin, the concept of this book was prompted by Kasimir Malevich's idea of the square as a generator of form. Language and layout are presented in a way that examines space and time — a kind of four-dimensional graphic. By using various sizes, weights, and fonts and dramatically exploring the angles between the format of the page and the elements placed upon it, Lissitzky gave considerable impact to the few words of his story, themselves at one with the illustration.

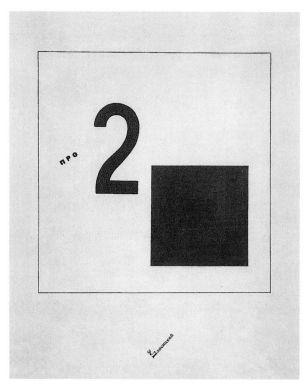

**1** FRONT COVER. ABOUT 2 SQUARES EL LISSITZKY

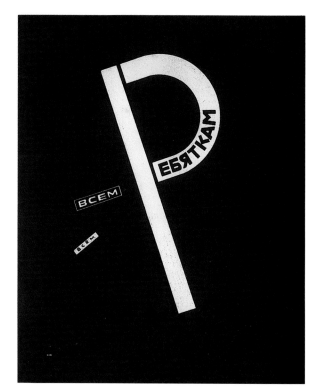

**2** DEDICATION: TO ALL, TO ALL YOUNG FELLOWS

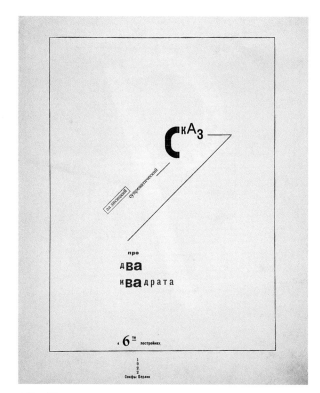

**3** EL LISSITZKY: A SUPREMATIST STORY — ABOUT TWO SQUARES IN SIX CONSTRUCTIONS: BERLIN, VERLAG SKYTHEN (BERLIN), 1922.

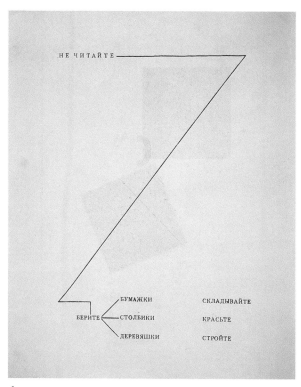

**4** DO NOT READ: TAKE — PAPER...FOLD; BLOCKS...COLOUR; PIECES OF WOOD...CONSTRUCT

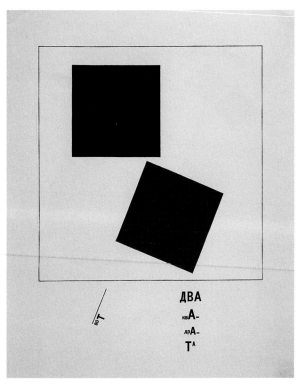

**5** HERE ARE — TWO SQUARES

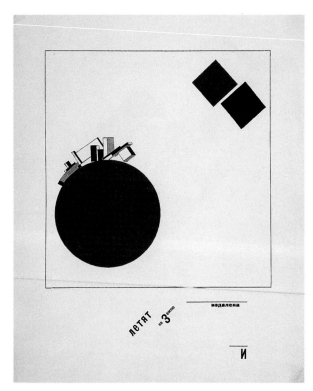

**6** FLYING TOWARDS THE EARTH — FROM FAR AWAY — AND

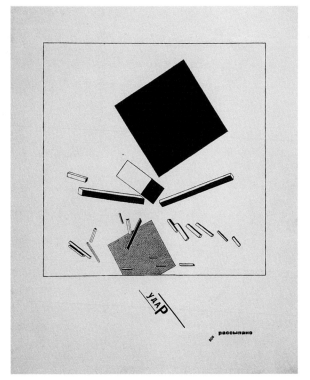

**7** AND — SEE — BLACK CHAOS

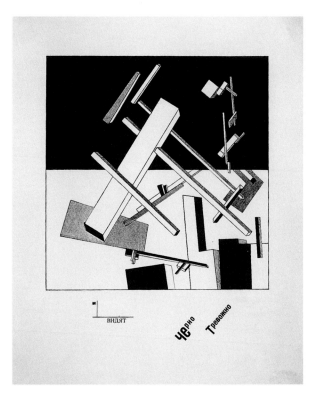

**8** CRASH — ALL IS SCATTERED

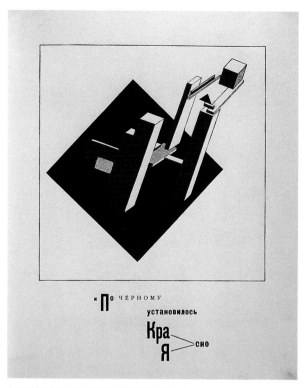

**9** AND ON THE BLACK WAS ESTABLISHED RED CLEARLY

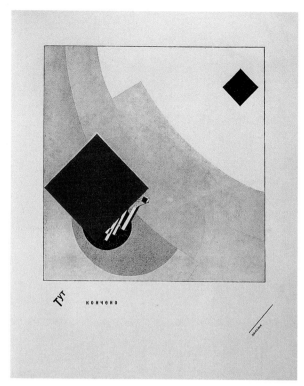

**10** THUS IT ENDS—FURTHER

**11** COLOPHON

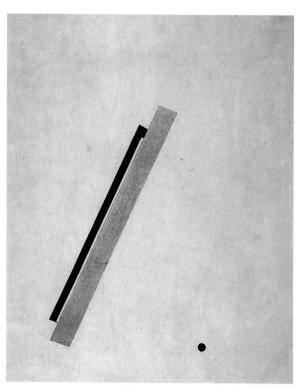

**12** BACK COVER

**NATALIYA GONCHAROVA** (1881–1962) RUSSIAN
*Grand Bal de Nuit,* 1923.
Poster / color lithograph.
Designed for Salle Bullier *Grand Bal des Artistes,* Paris, February 23, 1923.
Signed in lithography stone; N. Goncharova.
Height: 47 1/4 x Width: 28 7/8 in.
Collection of The Minneapolis Institute of Arts
The Modernism Collection. Gift of Norwest Bank Minnesota, 88-35

This Cubist-inspired poster is quite rare. It was designed by Nataliya Goncharova who, with Mikhail Fedorovich Larionov, initiated a new art movement in 1913 called Rayonnism (a synthesis of Cubism, Futurism, and Orphism) while in Russia. The couple left Russia in 1914 and settled in Paris, designing sets for Diaghilev's Ballet Russes. The Russian impresario was quick to engage many such painters to design his scenery and his posters. Their Montparnasse life often led to jointly organized galas and balls, and in 1923 Goncharova designed this poster for the *Grand Bal de Nuit.* Larionov designed the invitation, one of which is represented in this collection (p. 071).

The poster's composition is fragmented against a flat space with hard-edge silhouettes suggesting figurative elements. The manner in which the segments are aligned so that edges never quite butt together, permitting slivers of background to show through, prefigures similar compositional devices used so masterfully by Henri Matisse in his paper cutouts. Parallel with her paintings in near-abstract idioms, Goncharova produced theater and ballet décors inspired by Russian popular art. Her theatrical career, like that of Larionov, was bound up with that of Diaghilev, whose ballets from 1909 to the 1920s were a focal point of Paris cultural life.

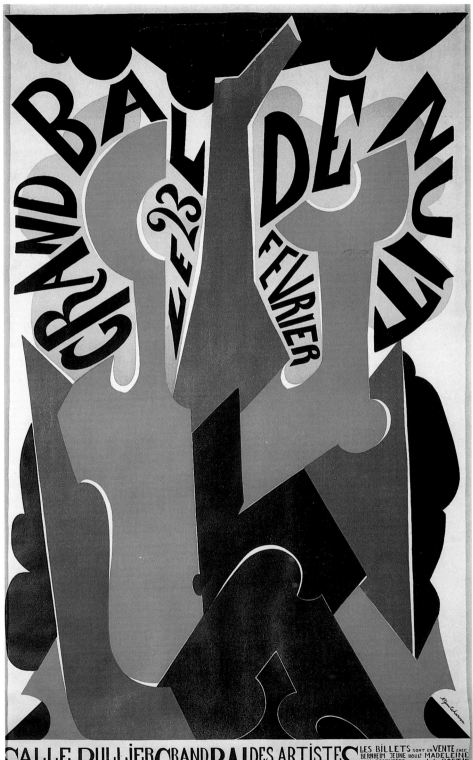

GRAND BAL LE 23 DE FEVRIER NU

SALLE BULLIER GRAND BAL DES ARTISTES
LE 23 FEVRIER  31 AVENUE DE  DE 9h DU SOIR  TRAVESTI-COSTUME
L'OBSERVATOIRE  A 5h DU MATIN  NON OBLICATOIRE

LES BILLETS SONT EN VENTE CHEZ:
BERNHEIM JEUNE BOUL! MADELEINE
PAUL ROSENRERC RUE LA BOETIE
PAUL GUILLAUME RUE LA BOETIE
ET AU BAL BULLIER

IMP JOSEPH-CHARLES. PARIS

**MIKHAIL FEDOROVICH LARIONOV** (1881–1964) RUSSIAN
*Invitation to* Grand Bal des Artistes, 1923.
Lithograph on cream paper.
Rubber-stamped on verso by the Union's treasurer: No. 469.
Height: 8 3/4 x Width: 10 3/4 in.
Collection of The Minneapolis Institute of Arts
The Modernism Collection. Gift of Norwest Bank Minnesota, 88-49

Mikhail Larionov entered the Moscow Academy in 1898, where he was to meet his life-long companion, Nataliya Goncharova. After participating in numerous avant-garde exhibitions in Russia he left with Diaghilev for Paris in 1914, where his work and that of Goncharova was shown in the Galerie Paul Guillaume. Thereafter, he devoted himself to the theater, where he felt his Rayist ideas received full expression.

This invitation accompanied the poster (p. 069) designed by Goncharova for the Paris ball organized by L'Union des Artistes Russes, February 23, 1923. The design is similar to an illustration by Larionov appearing in Vladimir Mayakovsky's *The Sun,* 1922. Each of Larionov's designs contains some letters from the title; the other letters can be "read" in the figures. The play on words seen here stems from the *zaum* ("transrational") language of the Russian Futurists, in which printed letters are arranged so as to suggest alternative meanings, disrupting conventional syntax and grammar and divorcing sound from immediate sense (possibilities of this approach to language were exploited by James Joyce in *Work in Progress* in the 1920s and in *Finnegans Wake*, but he had no known links with Futurism beyond a visit to a Futurist exhibition in Trieste when he lived there before 1914). Larionov claimed that this use of letters was inspired by shop signboards. French Cubists also used letters in a similar but less systematic way.

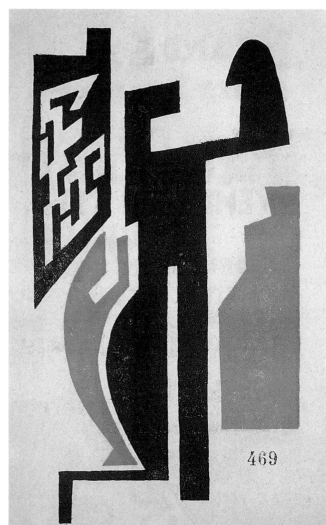

469

M. Larionow

GRAND BAL
DES ARTISTES

TRA VESTI
NS MENTAL
VENDREDI 23 FE
AV VRIER
PROFIT DE LA 1923
CAISSE DE SECOURS
MVTVEL DE L'VNION
DES ARTISTES RVSS
ES

BVLLIER          INVITATION
31 AVENVE DE
L'OBSERVATOIRE

DE 9 H. DV SOIR À 5 H. DV MATIN

**EL LISSITSKY** (Lazar Markovich Lissitzky) (1890–1941) RUSSIAN
*Dilia Golosa* (For The Voice or For Reading Out Loud), 1923.
A book of poems by the Russian poet/playwright, Vladimir Mayakovsky.
Gosizdat RSFSR (State Publishing House of the Russian Republic, Berlin), 62p.
Book design, paper covers, and illustrations by El Lissitzky. Edition of 3000.
Height: 7 1/2 x Width: 5 1/4 in.
Collection of The Minneapolis Institute of Arts
The Modernism Collection. Gift of Norwest Bank Minnesota, 89-27

In 1918, the radical poet Vladimir Mayakovsky campaigned for the separation of art and the state and for the self-government of art institutions in his treatise, *The Manifesto of the Flying Federation of Futurists*. Five years later, thirteen of his most frequently quoted poems were published in this remarkable edition in which the content was intended to be read aloud (hence the title). In order to facilitate reading aloud he asked El Lissitzky to design the book. It was published in Berlin where Gosizdat (State Publishing House) had a branch office at the time, and it was mechanically set—according to El Lissitzky's page-by-page sketch-layouts—by a German compositor who knew no Russian. In his essay *Typographic Facts,* Lissitzky described his method of design: "To make it easier for the reader to find any particular poem, I use an alphabetical (i.e. thumb-indexed) index. The book is created with the resources of the compositor's type case alone. The possibilities of two-color printing (with overlapping and cross-hatching) have been fully exploited: my pages stand in much the same relation to the poems as an accompanying piano to a violin. Just as the poet in his poem unites concept and sound, I have tried to create an equivalent unity using the poem and the typography."

A separate poem appears on each spread. The tabs on the right-hand side of the pages are die-cut and stepped to enable the reader find each one. They are in alphabetical order with symbolic codes linked to the relevant pages. Only materials already available to the typesetter were used: the shaping of some of the large characters are created from utilitarian rules, bars, and other devices used to lock up pages, along with vernacular printers' symbols such as engraved hand blocks to suggest page-turns (often used by modernist typographers to draw attention). The generous use of white space adds to the book's dramatic effect, permitting elements to float and to be carefully balanced. In this single volume, El Lissitzky has succeeded in applying his Constructivist ideas without compromise.

The poems convey Mayakovsky's revolutionary commitment and his capacity for humorous observations on urban life. The pace of the poems is matched by the typographic illustrations, which fully exploit the possibilities of two-color printing and typography. Each poem is given a symbolic typographic identity, and the relevant image is used on the thumb index — a convenient, witty guide to the contents. The poems include *Left March, The Third International, The Art Army, Love,* and *The Story of Red Riding Hood,* among others. They vary in subject from leftist political incitement to lyricism and wit, and in style from quick-paced rhythms to an almost expository clarity. El Lissitzky's pivotal role in typographic theory is generously acknowledged by Jan Tschichold in his seminal text *Die Neue Typographie,* 1928.

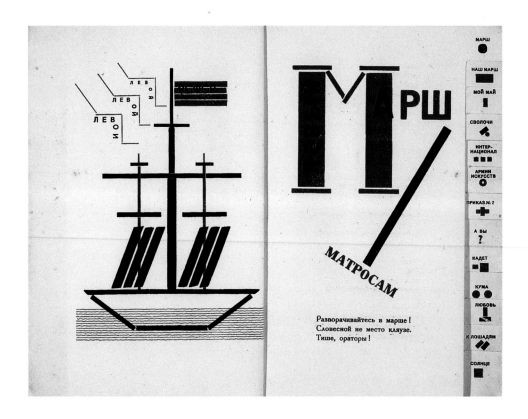

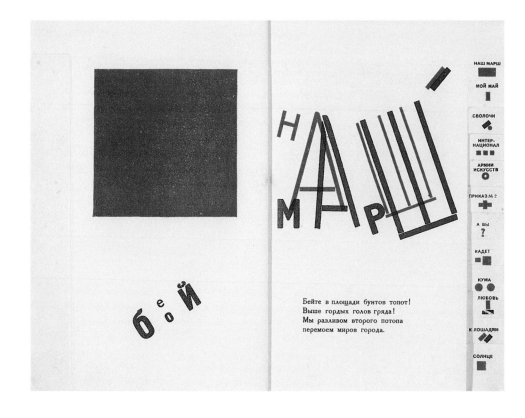

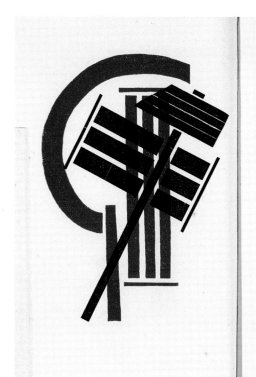

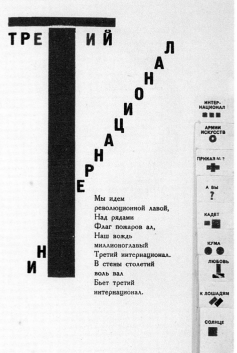

ТРЕТИЙ ИНТЕРНАЦИОНАЛ

Мы идем
революционной лавой,
Над рядами
Флаг пожаров ал,
Наш вождь
миллионоглавый
Третий интернационал.
В стены столетий
воль вал
Бьет третий
интернационал.

ИНТЕР-
НАЦИОНАЛ

АРМИИ
ИСКУССТВ

ПРИКАЗ № 2

А ВЫ
?

КАДЕТ

КУМА

ЛЮБОВЬ

К ЛОШАДЯМ

СОЛНЦЕ

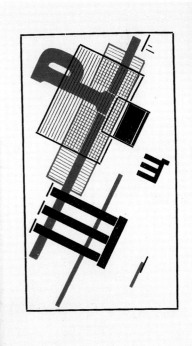

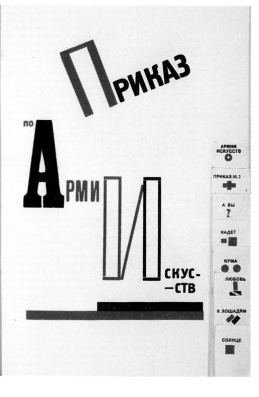

ПРИКАЗ по АРМИИ ИСКУС--СТВ

АРМИИ
ИСКУССТВ

ПРИКАЗ № 2

А ВЫ
?

КАДЕТ

КУМА

ЛЮБОВЬ

К ЛОШАДЯМ

СОЛНЦЕ

ЭТО ВАМ —

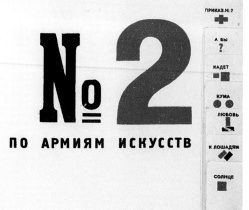

# ПРИКАЗ

# № 2

## ПО АРМИЯМ ИСКУССТВ

ПРИКАЗ № 2

А БЫ ?

КАДЕТ

КУМА

ЛЮБОВЬ

К ЛОШАДЯМ

СОЛНЦЕ

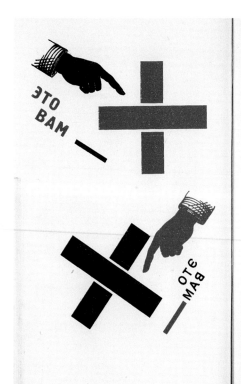

а вы могли бы ?

Я сразу смазал карту будня,
плеснувши краску из стакана.
Я показал на блюде студня
косые скулы океана.
На чешуе жестяной рыбы
прочел я зовы новых губ.
А вы
ноктюрн сыграть
могли бы
на флейте водосточных труб?

41

А ВЫ ?

КАДЕТ

КУМА

ЛЮБОВЬ

К ЛОШАДЯМ

СОЛНЦЕ

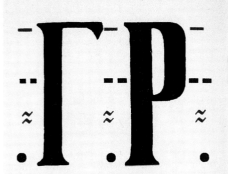

# ГР–ИАОУ–Бь

Хорошее
Отношение
к ЛОШАДЯМ

Били копыта
пели будто:
— ГРИБ
ГРАБЬ
ГРОБ
ГРУБ —

К ЛОШАДЯМ

СОЛНЦЕ

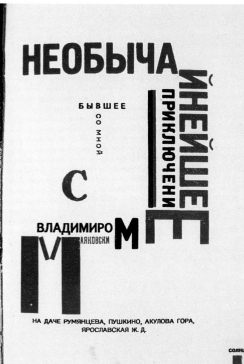

НЕОБЫЧАЙНЕЙШЕЕ
ПРИКЛЮЧЕНИЕ

БЫВШЕЕ
со мной

С

ВЛАДИМИРОМ МАЯКОВСКИМ

НА ДАЧЕ РУМЯНЦЕВА, ПУШКИНО, АКУЛОВА ГОРА,
ЯРОСЛАВСКАЯ Ж. Д.

СОЛНЦЕ

**ALEXANDER RODCHENKO** (Aleksandr Mikhailovich Rodtschenko) (1891–1956) RUSSIAN
*Mena Vsekh* (Exchange of All or All Change), 1924.
Poets include: K. Zelinskii, A. Chicherin, E.-K. Sel'vinskii, et al.
Publisher: Gosizdat, Moscow.
84p. Photos of all the authors.
Constructivist typography by the authors.
Printed paper covers.
Height: 7 x Width: 9 7/16 in.
Collection of The Minneapolis Institute of Arts
Gift of the Print and Drawing Council, 2000.130.2

In the early 1920s Alexander Rodchenko emerged as among the most influential designers associated with the Russian Constructivist movement following the 1917 revolution. He applied his considerable skills to interiors, stage sets, fashion, costume, and two-dimensional design, including textiles, book covers, posters, trademarks, and packaging. The challenge confronting graphic designers in post-revolutionary Russia was to introduce an arresting and easily understood graphic style for a general public with a high rate of illiteracy. Abstract concepts were illustrated using basic geometric shapes or symbols such as arrows. When Constructivist literature joined the visual arts, Rodchenko used a typographic design for the cover of the group's first anthology, which is variously titled *Exchange of All* or *All Change*.

Poems and essays are by various authors, who are identified as "constructors." Their declaration "Znaem" (Let Us Know) expresses a dedication to Constructivist organizations of forms. Zelinskii's section consists of an essay on the ideological and formal relationship of Constructivism and poetry. Sel'vinskii's seven poems at first seem traditional, but closer scrutiny reveals his search for new form and content. Chicherin's contribution comprises partially scanned poems, some printed in dynamic typography, plus Constructivist drawings and diagrams of music. Ultimately, Rodchenko's pioneering typography with its clear structure and geometric austerity was a noble attempt to spread the political message.

# МЕНА ВСЕХ

## КОНСТРУКТИВИСТЫ

## ПОЭТЫ

1924 · МОСКВА

**ALEXANDER RODCHENKO** (Aleksandr Mikhailovich Rodtschenko) (1891–1956) RUSSIAN
*L'Art Decoratif et Industriel de L'U.R.S.S.* Moscow / Paris: (GOZNAK), 1925.
Exhibition catalogue.
Cover design by Rodchenko.
One of several catalogues produced for the Russian section of the 1925 Paris Exposition des Arts Décoratifs et Industriel Moderne.
Height: 10¹/₂ x Width: 8 in.
Collection of The Minneapolis Institute of Arts
The Modernism Collection. Gift of Norwest Bank Minnesota, 89-12

Of the many catalogues produced by those countries participating in the celebrated 1925 international exposition in Paris, this one represents the Russian section. The illustrated articles provide an overview of the various decorative and industrial arts—from ceramics and textiles to books and theatrical designs—that were included, with special attention devoted to the Constructivist influence. The exhibition was the first major display of Soviet revolutionary art outside the Soviet Union.

Artist, designer, and photographer Alexander Rodchenko was a leading figure of Russian Constructivism. In 1921, he abandoned "pure art" in favor of a visual communication that "would serve the needs of society." His pioneering constructivist typography, with its geometrical severity, heavy rules, and bold, hand-drawn sans serifs, was inextricably linked with the politics of the Russian revolution. The cover design of this catalogue is typical of his work at the time. For the French, it was regarded as crude and heavy-handed, far removed from the Parisian *élégance* they touted as the theme of the show.

Rodchenko carried his design much further. He designed a reading room in the "Workers' Club," which was installed in the same Soviet Pavilion at the Exposition. One can well imagine what kind of reading material was made available. From the 1930s onwards, Rodchenko worked as a typographer and photo-journalist, contributing to magazines such as *USSR in Construction*. His contributions to modernist typography cannot be overemphasized.

L'ART DECORATIF

U.R.S.S.

MOSCOU-PARIS 1925

**EL LISSITZKY** (Lazar Markovich Lissitzky) (1890–1941) RUSSIAN and
**HANS ARP** (1886–1966) FRENCH
*Kunstimen* (Artisms), 1925.
Twelve pages of text with 48 pages of illustrations.
76 photographs of works by numerous 20th-century artists.
Typography and printed paper covers (over board) designed by El Lissitzky.
Eugen Rentsch Verlag, Erlenbach-Zürich, 1925.
Height: 8¹/₁₆ x Width: 10¹/₄ in.
Collection of The Minneapolis Institute of Arts
The Modernism Collection. Gift of Norwest Bank Minnesota, 89-47

Jointly designed by El Lissitzky and Hans Arp, this trilingual book was produced for the famous 1925 *Paris Exposition des Arts Décoratifs et Industriel Moderne* as an attempt to summarize and elaborately illustrate the major art movements (as well as some "movements" never heard of before or since), the *isms* of a ten-year period, from 1914 to 1924: Constructivism, Verism, Prouns, Compressionism, Merzbild, Neoplasticism, Purism, Dadaism, Simultaneity, Suprematism, Metaphysical Art, Abstraction, Cubism, Futurism, and Expressionism.

Inside, the book is aligned along a rigorous grid system dividing the *isms* into three columns per page, each given to a different language (German, French and English). The front cover closely resembles Russian posters which were so important as an advocacy art form both in Germany and Russia. The powerful "K" combined with the red "ISM" serves as a perfect shorthand printed in a solid block format. The interior design purposely contrasts various typefaces. More important than its function as an abbreviated survey of modern art movements, its stark graphic announcement is a reminder of how far the Russians pushed graphic design and typography during this brief period. This book is the last example of typography that Lissitzky produced outside Russia.

# K

## KUNST

## ISM

**1924**

FILM US
KONSTRUKTIV US
VER US
PROUN US
KOMPRESSION US
MERZ US
NEOPLASTIZ US
PUR US
DADA US
SIMULTAN US
SUPREMAT US
METAPHYSIK US
ABSTRAKTIV US
KUB US
FUTUR US
EXPRESSION US

**1914**

**VICTOR SHESTAKOV** (DATES UNKNOWN) RUSSIAN

**1** *Moscow Theater Festival,* c. 1933.
Poster / lithograph.
Printed for the Vsevolod Meyerhold State Theater, Moscow.
Height: 26 x Width: 36 in.
Collection of The Minneapolis Institute of Arts
The Modernism Collection. Gift of Norwest Bank Minnesota, 90-22

**2** *Invasion,* 1933.
Poster / color lithograph.
Printed for the Vsevolod Meyerhold State Theater, Moscow.
Height: 26 x Width: 36 in.
Collection of The Minneapolis Institute of Arts
The Modernism Collection. Gift of Norwest Bank, Minnesota, 90-23

Victor Shestakov was an active member of the "First Working Group of Constructivists" under the leadership of Aleksei Gan along with Grigori Miller, Aleksandra Miralyuova, L. Sanina, G. Smirrov, and Galina and Olga Chichagova. The group was apparently organized into different sections, working with furniture and equipment needed in everyday life, children's books, special clothing, and typographic production to which Gan, Miller, and Shestakov contributed. As with many of the Constructivists, the artist relied on solid fields of color (often black) with bold lettering devoid of any imagery whatsoever. There is an undeniable sense of purpose; the notion of subtlety or decorative elements was considered not only frivolous, but out of the national character.

The top poster (fig. 1) was designed for a theater festival running at Moscow's Vsevolod Meyerhold State Theater in early September, 1935. Meyerhold was the theatrical director (trained under Stanislavsky) as well as a leading Constructivist after the revolution. His theory of "Bio-mechanics" was the application of Constructivist ideas in theater staging. The plays included *The Forrest* by A.N. Ostrovskiy, *The Inspector General* by N.V. Gogol, and *The Lady with Camellias* by A. Dumas.

The bottom poster (fig. 2) is an announcement for Yuriy German's play *Invasion,* which ran February 1–3, 1933, with music by V. Ya. Shebalin. The posters share similarities in overall style, likely part of a series of posters produced that same year. But in this work, Shestakov introduces a dramatic diagonal and one inflated capital letter (M) to charge the design. Many agree that Constructivism achieved its most complete realization in these theatrical productions, and in Sergei Eisenstein's early films.

1

2

**KAZIMIR MALEVICH** (1878–1935) RUSSIA and
**OLGA ROZANOVA** (1886–1918) RUSSIA

1 *Vozopshchem* (Let's Grumble), 1913.
Lithographs, letterpress, photolithographic illustrations.
St. Petersburg, 1913, Svet, St. Petersburg.
1000 copies printed.
Height: 7 3/8 x Width: 5 5/8 in.
Collection of The Minneapolis Institute of Arts
Gift of the Print and Drawing Council and the Christina N. and Swan J. Turnblad Memorial Fund, B.90.7

**DAVID DAVIDOVICH BURLIUK** (1882–1967) RUSSIA and
**VLADIMIR BURLIUK** (1886–1917) RUSSIA

2 *Tragediya* (Tragedy), 1914.
Lithographs and letterpress.
Author: Vladimir Mayakovsky.
Futurist Hylaea, Moscow.
Height: 7 x Width: 5 1/4 x Depth: 3/8 in.
Collection of The Minneapolis Institute of Arts
Gift of the Print and Drawing Council and the Christina N. and Swan J. Turnblad Memorial Fund, B.90.4

**DAVID DAVIDOVICH BURLIUK** (1882–1967) RUSSIAN,
**VLADIMIR BURLIUK** (1886–1917) RUSSIAN, and
**ALEXANDRA EXETER** (1882–1949) RUSSIAN

3 *Futurists: First Journal of Russian Futurists, No. 1-2*, 1914.
Color lithography, photolithographs and letterpress.
Authors: Vladimir Mayakovsky, V. Shershenevich, David Burliuk, Velemir Khlebnikov, B. Livshits, Igor Severyanin et al.
Height 10 5/8 x Width: 8 x Depth: 1/2 in.
Collection of The Minneapolis Institute of Arts
The Ethel Morrison Van Derlip Fund, B.90.9

**ANTON MIKHAILOVICH LAVINSKY** (1893–1968) RUSSIAN

4 *Ne poputchitsa* (Not a Fellow Traveler), 1923.
Pamphlet in letterpress with photolithographic cover.
Author: Osip Maksimovich Brik.
Publisher: Left Front of Arts (LEF).
3000 copies printed.
Height: 9 x Width: 6 in.
Collection of The Minneapolis Institute of Arts
Gift of the Print and Drawing Council // 2000.130.1

1

2

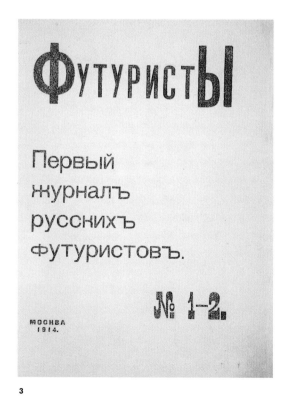

3

4

**HERBERT BAYER** (1900–1985) AMERICAN, BORN AUSTRIA and
**LÁSZLÓ MOHOLY-NAGY** (1895–1946) HUNGARIAN
*Staatliches Bauhaus in Weimar,* 1919–1923.
Exhibition catalogue, 1923.
Cover design by Bayer. Title page, layout, and typography by Moholy-Nagy.
Includes essays by Walter Gropius, Gertrud Grunow, Paul Klee and Wassily Kandinsky.
Published by Bauhausverlag, Weimar.
The edition called for 2600 copies of which 2000 were to be in German and 300 each in Russian and English, yet no copies of the latter two have ever appeared.
Height: 9 3/4 x Width: 10 in.
Collection of The Minneapolis Institute of Arts
The Modernism Collection. Gift of Norwest Bank Minnesota, 88-103

Herbert Bayer began his rise to prominence as one of the first generation of Bauhaus students from 1921 to 1923 studying under László Moholy-Nagy and Wassily Kandinsky. When the Bauhaus moved to Dessau in 1925, Bayer was appointed head of the new department of typography and advertising. His influence was immediate as he used Bauhaus publications as a vehicle for radical typographic ideas. He replaced the tendency toward decorative compositions with ordered and economical means, designed a sans serif alphabet, and championed the exclusive use of lowercase type, all giving Bauhaus publications their distinct character. His graphic designs of the late 1920s and 1930s were also influential due to his integration of typography and photography. Bayer was the leading advocate of sans serif typefaces, which became the typographic expression of modernity.

This landmark of modern typography was the first and only edition representing the comprehensive programmatic publications of the Weimar Bauhaus. Accompanying the important Bauhaus exhibition of 1923, it was designed to emphasize the school's new orientation to the applied arts. The book itself was a de facto example of the most advanced ideas about typography and established the principles of the school's new typography, if not its final resolution.

For the cover, Herbert Bayer (then an advanced student of Moholy-Nagy and Kandinsky) used rough, hand-drawn letters, dividing words into blocks of red and blue while condensing and stretching some forms and spacing to make the lines equal in length. In Bayer's division of colored letters he contradicted hard-line principles of uniformity by making the divisions of red and blue appear to be random, thereby drawing our eye even further to the words. Inspired by El Lissitzky and fellow constructivist designers, the book's interior layout indicates Moholy-Nagy's drive toward clarity. Red bar lines for division and emphasis, beige paper for text pages, and white paper for illustrative pages are employed along with carefully arranged documentary photographs, photographic reproductions, and original and reproduced works of art. The book (and exhibition) set off considerable public debate and criticism for its "shopwindow" effects, "brutal" color, and lack of "refinement in form."

# STAATLICHES BAUHAUS IN WEIMAR 1919-1923

**WALTER DEXEL** (1890–1973) GERMAN
*Verwende stets nur Gas* (Always use only gas…),1924.
Poster / color letterpress.
Designed for German State Gasworks.
Imprint: Dexel Jena.
Height: 20 x Width: 26 1/2 in.
Collection of The Minneapolis Institute of Arts
The Modernism Collection. Gift of Norwest Bank Minnesota, 88-33

After studying art in Munich, Walter Dexel soon devoted himself to commercial art and typography, designing advertisements and posters and developing lighted advertising for billboards. He collaborated closely with the Bauhaus (1919–1925), especially with Theo van Doesburg (1921–1923). In 1927, he organized the first exhibition of commercial art: *New Advertising*. Dexel began his career organizing exhibitions for Jena's Art Union and during those years arranged many shows for the artists of Die Brücke, Der Blaue Reiter, Der Sturm, and the neighboring Bauhaus. As a Constructivist painter, Dexel exhibited in Der Sturm in 1918, 1920, and 1925. He also took part in the international exhibitions in Moscow and Paris. He taught at Magdeburg (1928–1935) and at the Berlin-Schöneberg National School of Art (1936–1942).

This poster was a promotional piece urging consumers to use gas in the home. Full text of the poster reads: "Always use only gas for cooking, baking, heating, and lighting because it is practical, clean, and cheap. Saves work, time, and money. Information and exhibition in Municipal Gas Works." Black, yellow, and red, tough no-nonsense colors, are used with blocks of type—all in caps—which float in various alignments, but all are subservient to the powerful exclamation point. The word *GAS* is effectively emphasized, a shorthand message in letterform. As with the other artists identified with the Bauhaus, particularly Herbert Bayer and Joost Schmidt, asymmetry is used fluently, and the lettering is dynamically composed taking on a function previously filled by images.

The exclamation point became a familiar graphic device used by the Futurists, Dadaists, De Stijl artists (to a lesser degree), and the Russian Constructivists (for whom it was a powerful means of asserting the message). Normally the dot and extender are never joined. By the eighteenth century, the exclamation point became a generally accepted and consistently used punctuation mark. The initial configuration (referred to as a "bang" or a "screamer" by vintage printers), which is also descended from a logotype for the Latin word *io* (joy), was a capital I set over a lowercase o. Gradually, as with the question mark, the design of the exclamation point was reduced to its present form.

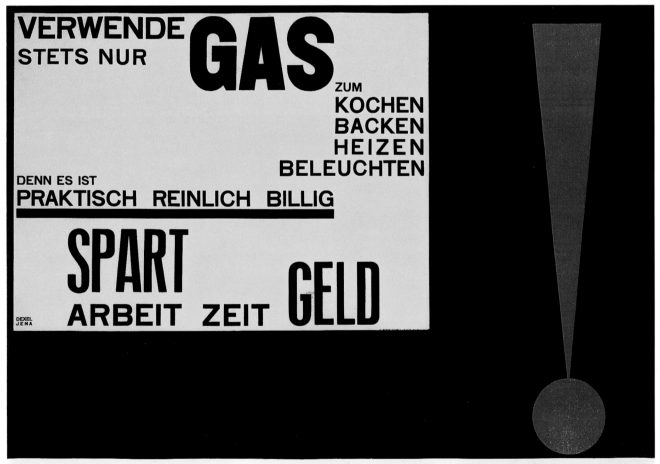

**WALTER DEXEL** (1890–1973) GERMAN
*Figuration Fj,* 1925.
Gouache.
Marks: signed, dated and titled, Figuration Fj on reverse.
Height: 9 x Width: 4 1/4 in.
Collection of The Minneapolis Institute of Arts
The Modernism Collection. Gift of Norwest Bank Minnesota, 88-102

Executed the year following his *Gas* poster (p. 091), no docu-
mentation has surfaced that explains the purpose of this compo-
sition. It is titled *Figuration Fj,* however, and quite likely was a
typographical exercise. Or, possibly, it may have been a rendering
for a commissioned piece, a stationery letterhead or monogram,
or perhaps for an organization or company logo. Its utter simplic-
ity yet visual punch is quite remarkable. A full capital F nicks the
corner of the skinny j form printed in red. The outside edge of the
j meets with the bottom edge of the F, thereby creating a curva-
ceous negative space, an antidote to the otherwise severe
angularity of the overall design.

**HERBERT BAYER** (1900–1958) AMERICAN, BORN AUSTRIA
*Europäisches Kunstgewerbe,* 1927.
Poster / color lithograph.
Printed for Exhibition of European Arts and Crafts, Leipzig, 1927.
Printer: Ernst Ahedrich Nachf, Leipzig,
Height: 22⁷/₈ x Width: 35 in.
Collection of The Minneapolis Institute of Arts
The Modernism Collection. Gift of Norwest Bank Minnesota, 89-46

The principles of Bauhaus typography are most clearly illustrated in the *bauhaus* magazine, beginning in 1926, and the series of thirteen books published by the school. Herbert Bayer, Professor of Typography (1925–1928), developed a radical new typographical style. Sans serif typefaces were used almost exclusively and words were given emphasis through contrasts in the size and weight of characters. Colors were restricted to black and white and one primary color, usually red.

This famous poster was designed by Bayer for an exhibition of European applied arts (*Europäisches Kunstgewerbe*) at the Leipzig Grassimuseum in 1927. Using typography both as text and as pattern, Bayer combined form and content as one. This poster and his cover of the accompanying exhibition catalogue have become two long-standing classics of Bauhaus graphics. Bayer's finest work is found in the fresh, tightly organized, yet irreverent typography appearing in Bauhaus posters. He invented his own typefaces, introducing the *Universal* alphabet of 1925 (which he revised in 1927), the standardized geometrical forms characteristic of the Bauhaus ethic. Typography was a lifelong interest for Bayer, and though he consistently held to his early rejection of capital letters, his designs were never dogmatic. Over a lifetime he was able to incorporate many typefaces into his graphic designs without feeling obliged to make pronouncements of perfected form. In this, as in all phases of his creative activity, he was very much a pragmatist.

AUSSTELLUNG
EUROPÄI-SCHES
KUNST-GEWERBE
1927

herbert bayer bauhaus

6. MARZ
bis
15. AUG.

LEIPZIG

GRASSIMUSEUM
an der Johanniskirche

Buch-u. Kunstdruckerei Ernst Hedrich Nachf. Leipzig C.1

**LUCIEN BERNHARD** (Emil Kahn) (1883–1972) AUSTRIAN-GERMAN
*Adler* (typewriters), 1908.
Poster.
Height: 26¼ x Width: 36⅛ in.
The Collection of The Minneapolis Institute of Arts
The Modernism Collection. Gift of Norwest Bank Minnesota, 88-115

Born in Vienna, Lucien Bernhard's real name was Emil Kahn. He studied at the Munich Academy, which became a center of poster design. His principal talents were for lettering (a number of type-fonts were named after him: *Antiqua,* 1911; *Fraktur,* 1913; *Cursive,* 1925; *Gothic,* 1930; and *Tango,* 1930). In 1910 he was co-founder of the magazine *Das Plakat* (The Poster). In his pre-war poster for Adler typewriters, he employed a form of lettering similar to that used by the Beggarstaffs (rounded and with serifs added), but for his war posters he favored a dynamic gothic letter. His slogans and captions are generally the most important element; when an illustration is employed, it is perfectly inte-grated with the lettering—subservient almost—and seems to take on a kind of calligraphic character of its own.

To maximize the effect of the poster medium when viewed at a distance, Bernhard simplified forms, eliminated half-tones, and created what he called a *Sach Plakat* (object poster) formulated in 1905. In doing so he established his own poster style and brought about a revolution in advertising. The striking off-key orange background contrasted with the off-center "still life" portrait of a typewriter in muted lavender are shocking for their time. While it represents an exception to those works selected on the basis of typography only, the image here is incidental to the one-word heading, "Adler."

It is in his industrial graphics that Bernhard perfected a presenta-tion based on pure contrasts. He also favored a framing system (border around the trademark) showing silhouettes and strong diagonals. The easy appeal of his graphics conveys a "longed-for tranquillity" described by Deipynos in *Moderne Reklame* (1904): "The eye should not be offered nervosity, but tranquillity: a point to which it can hold, in which it can take refuge from all the tumult presented to it."

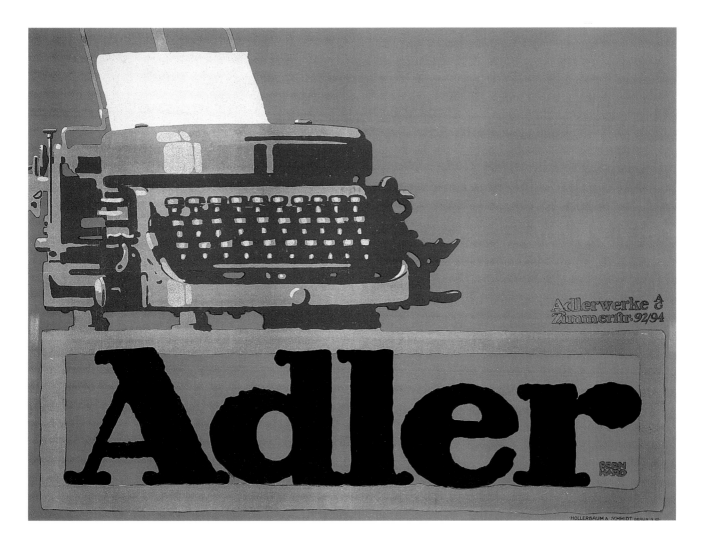

**KEES VAN DER LAAN** (DATES UNKNOWN) DUTCH
*Graf-Spee Landing,* 1932.
Poster / color lithograph.
Printer: Offsetdruk Kuhn & Zn, Rotterdam.
Height: 44 x Width: 32 in.
Collection of The Minneapolis Institute of Arts
The Modernism Collection. Gift of Norwest Bank Minnesota, 88-114

This commanding poster served as a public announcement for the June 18, 1932, arrival of the great zeppelin *Graf-Spee* at Wal-haven-en-Twente in The Netherlands. The two lower sections of the poster were reserved for additional write-in copy, noting the anticipated time of the airship's mooring. Kees Van der Laan, no less than the great posterist A. M. Cassandre, was able to capture the immense scale of the zeppelin by extending its image beyond the poster edge rather then centering it. As a compelling graphic image, it is quite equal to the task of heralding the arrival of what must have been an awesome sight in its day.

As with the *Adler* poster by Lucien Bernhard (p. 097), it does feature an image—an exception to the works selected for this survey—but it is almost secondary to the "shouting" typographical announcement, *LANDING.* In the composition, Van der Laan established a pattern of repeated horizontal bars, each running from side to side. The format runs counter to conventional compositional layout of the period yet proves to be an extremely effective graphic device.

GRAF ZEPPELIN

ZATERDAG **18** JUNI

LANDING

VLIEGVELDEN WAALHAVEN EN TWENTE

KEES VDER LAAN '32

OFFSETDRUK KUHN & Zⁿ R'DAM

**DESIGNER UNKNOWN** SWEDISH
*1930 Exposicion de Estocolmo,* 1929.
Poster / color lithograph.
Printer: Ivan Haeggstroms, Stockholm.
Height: 32 x Width: 24 1/4 in.
Collection of The Minneapolis Institute of Arts
The Modernism Collection. Gift of Norwest Bank Minnesota, 89-69

In 1930 Stockholm was the site of an important international forum for Modernism, the famed Stockholm Exhibition, in which the Swedes had "gone bolshy," converting to *funkis*—the Swedish term for functionalism. The exhibition was intended to sing the praises of the "practical" as well as the "humanist" qualities found in the housing and design policies supported by state and local authorities. It was quite apparent there was a pervasive rejection of an essentially national tradition that had established Sweden's reputation for design—"Swedish Grace," as it was affectionately called. A primary reason for Sweden's bold step into modernity was the country's positive acceptance of the machine and the machine aesthetic. In the minds of many the Swedes were turning their back on the past (an honorable past at that) and using their native resources to create the ideal conditions for a democratic future.

This colorful poster (the designer remains unknown) incorporates the colors of the Swedish flag as a top bar and uses a distinctive circular type for the date, 1930. It was the template for all participating countries, each inserting their respective copy in the bottom segment (this representing the Spanish delegation). The posters were designed to provide a unified format and to carry at a long distance; thus no imagery. The Swedes were especially successful in maintaining a human touch and handcraftsmanship in what was otherwise mass-production. They achieved this ideal with very little compromise, as their success in the 1950s and 1960s demonstrated.

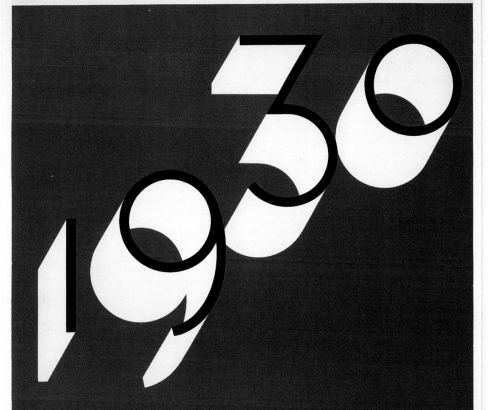

1930

EXPOSICION
DE ESTOCOLMO
1930 ARTES INDUSTRIALES ARTES
APLICADAS E INDUSTRIAS
CASERAS SUECAS
MAYO - SEPTIEMBRE

# Aa ₁ Aa ₂ Aa ₃ Aa ₄ a ₅

## MODERNIST TYPEFACES
### 1900-1957

Countless products of the twentieth century are associated with a particular lettering style, be they cereal boxes, newspapers, or corporate logos. So powerful is the impact of many typefaces that words are often given expression before the literal meaning becomes apparent. There are two basic divisions of typefaces: serif (those with terminal strokes) and sans serif (those without terminal strokes). There are also a multitude of variations. Some well-known modernist typefaces that have changed the way we see letterforms are listed below. Many of them have become – and remain – indispensible to today's finest graphic design.

**1 AURIOL**, c. 1900. Born Jean-Georges Huyot (1863–1938), Art Nouveau's most famous typographer changed his name to Georges Auriol. Friend and contemporary of Henri de Toulouse-Lautrec, he is perhaps best remembered for his calligraphic-like typeface, *Auriol,* made by Deberney & Peignot. It quickly became the most successful and prominent Art Nouveau typefont. Much of its popularity was due to its Oriental flavor, an important component (Japonisme) of the Art Nouveau style.

**2 ECKMANN-SCHMUCK**, 1900. An organic and calligraphic type prevalent during the Art Nouveau (Jugendstil) period. Designed by German typographer Otto Eckmann (1865–1902), the curvilinear strokes of each letter taper and swell, as if with the movement of an italic pen. Devised initially for the Rudhard Foundry, it was also adopted by Klingspor, with which it is most commonly associated.

**3 FRANKLIN GOTHIC**, 1903. After training as a mechanic and engineer, Morris Fuller (M. F.) Benton (1872–1948) went to work for American Type Founders Company (ATF), ultimately becoming its designer-in-chief. ATF was the most important typography company in the country at the time, employing many famous designers such as Lucien Bernhard. Benton soon became a prolific and creative typeface designer; in the first decade of the twentieth century he designed a number of very successful sans-serif typefaces including *Franklin Gothic* (1903). In his career he developed over 200 typefaces for ATF.

**4 UNDERGROUND**, 1915. Edward Johnston (1872–1944), an English master of calligraphy, was commissioned by London Underground to design a display typeface. He produced a sans serif alphabet that is quick to recognize and easy to read; it is still used by the London Underground today. The typeface is deployed to great effect on the roundel, which appears throughout the system to indicate each station name.

**5 UNIVERSAL**, 1925. During his time as head of the print department at the Bauhaus, Austrian Herbert Bayer (1900–1985) produced this alphabet. An advocate of modernism, Bayer defended the sans serif typeface as an expression of its time. He denounced serifs as a hangover from handwriting, incompatible with modern typography and printing. His simple, geometric *Universal* alphabet also suspended the use of capital letters. It was employed in the Bauhaus publication *Offset,* but never released as a typeface.

**6** **Aa** **7** Aa **8** Aa **9** Aa **10** **Aa**

---

**6 STENCIL**, 1925. As with Bayer's *Universal* font, Josef Albers's (1888–1976) *Stencil* typeface was an attempt to create an alphabet with very broad applications. And, similarly, its primary aims were universality and simplification. His Bauhaus principles have influenced generations of design students and remain a constant point of reference.

**7 FUTURA**, 1927–1930. The design of the *Futura* typeface owes more to precision engineering than to the calligrapher's pen. Taking inspiration from Bayer's *Universal* face, German typographer Paul Renner (1878–1956) was among the first to utilize the revolutionary approach of a completely even stroke throughout the alphabet. *Futura* is notably more rigid in its geometry than its corresponding British typeface, *Gill Sans*. As with *Universal,* the letterforms are based on squares and circles but, interestingly, the crossbar of the "E" and "F" is positioned above center. The typeface is used today in a number of variations.

**8 GILL SANS**, 1928. British designer Eric Gill (1882–1940) was a highly respected type designer, sculptor, and letter cutter. He studied under Edward Johnston (see *Underground*), whose influence is evident in the forms of this sans serif alphabet. Readily identified with modernism, subtle stroke variations give the face considerable fluidity, making it quite readable as continuous text. *Gill Sans* was created for the Monotype Company (renamed the Monotype Corporation in 1931).

**9 TIMES NEW ROMAN**, 1931. As well as advising Monotype Corporation, Stanley Morison was typographic consultant to *The London Times* for three decades, when he created this typeface for the newspaper. It was used exclusively by the paper for one year, replacing a Gothic type that had been favored for over 120 years. By simplifying the formation of each letter, the text could be condensed – saving considerable space – yet, importantly, remaining highly legible.

**10 UNIVERS**, 1957. Although designed after the period represented in this book and accompanying exhibition, special note should be made of the Swiss designer Adrian Frutiger (b. 1928), who earned considerable respect for the creation of this versatile typeface. Infinitely adaptable, numerous variations of the font permit a multitude of combinations and effects. Designed for the purpose of filmsetting, *Univers* is particularly compatible with printing in condensed spaces and has frequently been the preferred choice of timetables. In expanded, bolder format, it has been used for large-scale, public signage systems. The font is sans serif, with the right stress balanced on both vertical and diagonal strokes. Univers was taken up by the Monotype Corporation soon after it was launched.

# SUGGESTED READING LIST

The books listed below are among those consulted for this publication and exhibition. It is a representative selection of current titles that address modernist typography. Most of them are readily available and considered to be of interest to the student, layman, graphic designer, and collector. Those wishing to pursue the subject further are encouraged to investigate books examining Modernism as a broad subject, or those movements and styles commonly associated with Modernism. Moreover, one-man exhibitions have been devoted to seminal artists such as Alexander Rodchenko and El Lissitzky at major museums. The related exhibition catalogues provide important insights on their graphic work.

Books on posters also provide an exceptionally rich resource on graphic design and typography; they too should be consulted. Lastly, this list is limited to books only. A limitless number of pertinent articles and essays have been published during the past decade. By consulting bibliographies in the books listed below the reader will find many more avenues to explore in the field of modernist typography.

Ades, Dawn et al. *The 20th-century Poster: Design of the Avant Garde.* Abbeville Press, New York and Walker Art Center, Minneapolis, 1984. A comprehensive examination of the most advanced posters from turn of the century to the present, many preoccuped with elements of lettering and typography. Emphasis is less on representation than on artistic quality. A superb guide for collectors.

Apicella, Vincent F. et al. *The Concise Guide to Type Identification.* Lund Humphries Publisher, Ltd., London, 1990. As noted, a quick and easy guide to identifying typefaces, 1,700 all total. It provides full alphabets, upper and lower case, grouped by the same eight categories Linotype uses in the display of its library.

Blackwell, Lewis. *20th-Century Type.* Rizzoli International Publications, New York, 1992. Tracing the development of twentieth-century typeforms through the key figures while documenting their influence on one another.

Broos, Kees and Paul Hefting. *A Century of Dutch Graphic Design.* MIT Press, Cambridge, MA, 1993. Perhaps too specialized for some, but a fine example of book design in itself while providing many exemplary Dutch designs; too few realize how innovative Dutch graphic designers were in the early twentieth century. Here is ample evidence.

Campbell, Alastair. *The Designer's Lexicon: The Illustrated Dictionary of Design, Printing and Computer Terms.* Chronicle Books, San Francisco, 2000. A must for students of graphic design and working professionals as well as the curious minded. An up-to-date dictionary and guide to advances in typography as well as printing, lay-out production, desktop publishing, and editing. Clear, concise, comprehensive and admirably presented from cover to cover.

Carter, Sebastian. *Twentieth Century Type Designers.* Taplinger Publishing Co., New York, l987. For those wishing to know about the principal typographers of the twentieth century, this will provide a good introduction, from Frederic Goudy (1865–1947) to Adrian Frutiger (b. 1928).

Compton, Susan. *Russian Avant-Garde Books, 1917–1934.* The MIT Press, Cambridge MA, 1993. A review of the books that revolutionized Russian graphic design. It is an indispensible source for the serious student and a model of research scholarship.

Craig, James and Bruce Barton. *Thirty Centuries of Graphic Design: An Illustrated Survey.* Watson-Guptill Publications, New York, 1987. A solid introduction to typography through the ages with four of fifteen chapters devoted to the modernist period.

Friedl, Fredrich, Nicolaus Ott and Bernard Stein. *Typography: An Encyclopedic Survey of Type Design and Techniques Throughout History.* Black Dog and Leventhal Publishers, Inc., New York, 1998. As the title indicates, far more comprehensive than modernist typography, but what an eduction it is. Consists of brief thumb-nail biographies and explanations with a superb array of full-color illustrations. If you want visual proof that there is more to typography than meets the eye, herein lies the proof. Highly recommended.

Gottschall, Edward M. *Typographic Communication Today.* International Typeface Corporation, New York and MIT Press, Cambridge, MA, l989, 1991. A beautifully produced book focusing on what matters in content: typography and communication. A visual treat from cover to cover. If you're not a devotee of typography, you might become one after perusing this fine publication.

Haley, Allan. *Alphabet: The History, Evolution and Design of the Letters We Use Today.* Watson-Guptill Publications, New York, 1995. A brief overview of the Latin alphabet, letter by letter. Amply illustrated with most of today's popular typefaces. Quite instructive from a visual standpoint.

Heller, Steven and Seymour Chwast. *Graphic Style from Victorian to Post-Modern.* Harry N. Abrams, New York, 1988. A model of innovative graphic design itself with complimentary reviews: "A fascinating visual compendium," *The New York Times;* "A respected reference source...and a fascinating book," *Choice;* and, "A book on graphic style that is itself an expression of graphic style," *Library Journal.*

Heller, Steven and Louise Fili. *Typology: Type Design from the Victorian Era to the Digital Age.* Chronicle Books, San Francisco, 1999. Recommended for those wishing to investigate modernist typography further. "A resplendent tour through the last 150 years of type design." With sections divided by countries, it's informative and quite easy to use.

Hollis, Richard. *Graphic Design: A Concise History.* Thames and Hudson Ltd., London, 1994. Just what it says and with some 800 illustrations, 29 in color; a pleasure to peruse. Interestingly, the author was also the designer.

King, Julia. *The Flowering of Art Nouveau Graphics.* Peregrine Smith Books, Salt Lake City, 1990. A little specialized, but no less interesting to those wishing to know more about modernist graphic design and typography. Includes not only French, German, British, Italian, and American designs but those of Austria-Hungary, Poland, Russia, Scandinavia, and Spain. The emphasis is principally on poster art.

Lawson, Alexander. *Anatomy of a Typeface.* David R. Godine, Boston, l990. Not for everyone perhaps, but a thorough and enjoyable look at typographers, graphic artists, and "others of that lunatic fringe who believe that the letters we look at daily (and take entirely for granted) are of profound importance." Here is an exploration of the vast territory of types, their development and uses, their antecedents and offspring, presented with insight and clarity, from Garamond and Bembo to the designers and manufactures of sans serif letters.

Livingston, Alan and Isabella. *The Thames and Hudson Encyclopaedia of Graphic Design & Designers.* Thames and Hudson Ltd., London, 1992. With 445 illustrations, 59 in color, this handy guide is not only useful, it is a divertissement in itself.

Lupton, Ellen and Elaine Lustig Cohen. *Letters from the Avant Garde: Modern Graphic Design.* Princeton Architectural Press, New York, 1996. Somewhat more specialized but no less fascinating, a look at typography (and graphic design) through the medium of printed stationery. Featuring letterheads and other ephemera, the work of Herbert Bayer, El Lissitzky, László Moholy-Nagy, Kurt Schwitters, and Piet Zwart is represented.

McAlhone, Beryl and David Stuart. *A Smile in the Mind.* Foreword by Edward de Bono. Phaidon Press, London, 1996, 1998. Not exactly pertinent to the subject of modernism, but most certainly true to its ad: "...witty thinking in graphic design." For those who may have lingering doubts that typography and graphic design can be amusing. Recommended for diverson and edification.

Meggs, Philip B. *A History of Graphic Design.* Third edition, 1998. John Wiley & Sons, Inc., New York. A standby for course work on graphic design. A comprehensive overview and a long-standing reference tool for all aspects of graphic design. Superbly researched and written. Amply illustrated as well. A must for all libraries.

Neuenschwander, Brody. *Letterwork: Creative Letterforms in Graphic Design.* Phaidon Press, London, 1993, 1994. While not relevant to modernist typography, it does address the issue of bringing together the graphic designer and typographer. As such it would be of interest to students and graphic designers if not the layman.

Perfect, Christopher and Gordon Rookledge. *Rookledge's International Typefinder: The Essential Handbook of Typeface Recognition & Selection.* PBC International, Inc., New York, 1986. More difficult to find than most books listed here, but worth the effort for the student and professional. It includes over 700 type specimens, all fully cross-referenced to a comprehensive index. Other compendiums of type styles serve equally well. Simply a reminder that such useful guides are available for the layman. And today with the PC, everyone is well advised to become better informed about the individual styles and how best to apply them in all uses.

Rothenstein, Julian and Mel Gooding, eds. *Alphabets & Other Signs.* Shambhala, Boston, 1993. For those seeking a good time, this book is for you. Printed exclusively in black and white, it contains several brief essays, but the funky alphabets provide the principal story.

Spencer, Herbert. *The Liberated Page.* Foreword by Aaron Burns. Lund Humphries, London, and Bedford Press, San Francisco, 1987. An anthology of major typographic experiments of this century as recorded in *Typographica* magazine. A celebrated book in the field of typography, it presents essays examining many of those designers represented in this book and exhibition.

Spencer, Herbert. *Pioneers of Modern Typography.* Lund Humphries, London and The MIT Press, Cambridge, MA, 1969, 1982, 1983, 1985. A long-standing primer on avant-garde typography examining the work of the ten most influential typographers, all represented in this book and exhibition.

Swann, Alan. *Layout Source Book.* A Quarto Book. Wellfleet Press, Secaucus, NJ, 1989. An inviting overview of modernist graphic design – including typography – dating from 1880 to the present. As in all their "Source" books, content, layout, and illustration are thoughtfully composed, and always a pleasure to thumb through.

Tschichold, Jan. *The New Typography.* Translation by Ruari McLean. Introduction by Robin Kinorss. University of California Press, Berkeley, 1998. The first English translation of this revolutionary 1928 document.

Williams, Robin. *The Non-Designer's Design Book: Design and Typographic Principles for the Visual Novice.* Peachpit Press, Berkeley, CA, 1994. A gem of a book that is what it claims to be, all that and with wit and sass. A visual delight as well.

Wrede, Stuart. *The Modern Poster.* The Museum of Modern Art, NY, 1988. A superb overview of the twentieth-century poster plentifully illustrated with full-color examples of the very finest in poster art. Excellent historical overview and comprehensive bibliography.

# INDEX